Images of Modern America

CHATHAM

TO BETTY

WITH REGARDS,

ALAN POLLOCK

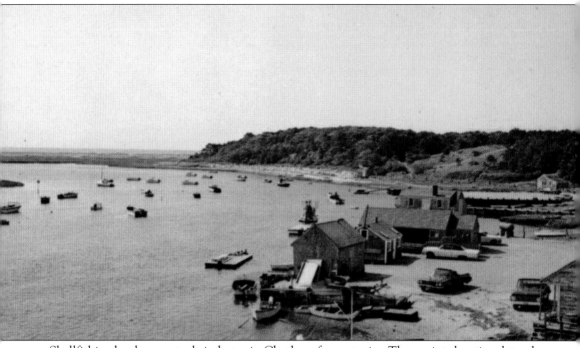

Shellfishing has been a staple industry in Chatham for centuries. The quaint shanties along the Oyster River provide refuge for fishermen as they clean and shuck the day's harvest of quahogs, littlenecks, scallops, or oysters. The shanties remain today, flanked by large houses; in the summertime, the river is crowded with pleasure boats. (Courtesy of Joan Tacke Aucoin.)

FRONT COVER: A stroll along the Oyster River in 1974 (Courtesy of James J. Dempsey)

UPPER BACK COVER: A storm buffets North Beach in January 2008 (Photograph by author, courtesy of the *Cape Cod Chronicle*)

LOWER BACK COVER (from left to right): The lighthouse overlook in the late 1950s (Courtesy of Joan Tacke Aucoin), Coast Guard Station Chatham in 1961 (Courtesy of Melissa Kraycir), and band concert night in 1976 (Courtesy of James J. Dempsey)

Images of Modern America

CHATHAM

Alan Pollock

ARCADIA
PUBLISHING

Copyright © 2016 by Alan Pollock
ISBN 978-1-4671-1612-1

Published by Arcadia Publishing
Charleston, South Carolina

Printed in the United States of America

Library of Congress Control Number: 2015951849

For all general information, please contact Arcadia Publishing:
Telephone 843-853-2070
Fax 843-853-0044
E-mail sales@arcadiapublishing.com
For customer service and orders:
Toll-Free 1-888-313-2665

Visit us on the Internet at www.arcadiapublishing.com

For Jim Stefanski, who has done so much more
than merely overcome adversity

CONTENTS

ACKNOWLEDGMENTS

I am not from Chatham. My home town is Hyannis, which was a far quieter, cleaner, and safer place in the 1970s than it is today. My first observations of Chatham were made through the rear windows of the blue station wagon that made weekly trips to my grandmother's toy and book store, Lorania's, in the building currently occupied by the Black Dog gift shop. Since I was much more interested in the cargo of new toys than the scenery we passed, I remember mostly that the trip down Route 28 from the main store in Hyannis was impossibly long. Bouncing up the hill by the white-columned church at Queen Anne Road meant that we were almost at our destination, where we would be greeted by Kay McMillan, the nice lady who managed the store.

Having reported on community life in Chatham for the *Cape Cod Chronicle* since 1996, I sometimes feel I know this town better than I know the one where I live: Brewster. When I agreed to compile this book, I was quite unfamiliar with the term *crowdsourcing*. But I put out the call for photographs and was pleased by the response.

I appreciate the contributions of the dozens of people who opened to me their homes, their dusty photo albums, and their snapshot-filled shoeboxes. Many of those who shared pictures also shared with me family stories and personal reminiscences of life in Chatham. To all the contributors, including those whose photographs were not included in the finished book, I offer my heartfelt thanks. While most of the photographs and reminiscences in this book come from contributors, any mistakes are mine alone.

I also thank Hank Hyora and Tim Wood at the *Cape Cod Chronicle* for allowing me to use photographs from the newspaper's archives. Images not otherwise credited come from this collection. Thanks also to colleague Kat Szmit for proofreading. As it enters its 50th year in print, the *Cape Cod Chronicle* continues to be a vibrant and important part of Chatham, and I am proud to be part of it.

INTRODUCTION

Any story about Chatham, Massachusetts, must begin and end with the sea, which has drawn vacationers, fishermen, adventurers, sailors, and retirees to the town for decades. In a very real sense, the Atlantic Ocean is a common tie that binds the community together, economically and socially—but also temporally.

The photographs in this book prove that Chatham looks different than it did 50 years ago. Gone is the Howard Johnson's at the rotary that served up delicious greasy hamburgers and French fries, and gone too is the likelihood of another fast-food chain restaurant ever opening downtown. Gone are most of the camps on North Beach. For decades, their owners bartered and bargained with the Cape Cod National Seashore to keep the cottages, savoring every season in them, only to eventually lose them to the encroaching Atlantic. Gone are the dune buggy races and countless other forms of raucous fun that fell victim to government rules or fear of litigation.

But visually, the change in Chatham has been less pronounced than one might expect. Summer life in Chatham is largely the same as it was in 1966, with sunbathers drawn to Harding's Beach, boaters plying Pleasant Bay and Nantucket Sound, and commercial fishermen working at either Aunt Lydia's Cove or Stage Harbor. Cloudy summer afternoons still mean lots of shoppers downtown, though the fashions—and the price tags—have changed.

In the downtown area and in the traditional village centers, Chatham's streetscape is much as it was a half-century ago. Stately historic houses were converted to inns or restaurants to serve vacationers and day-trippers but are now being converted back to luxury homes. Those same summer visitors were drawn back to Chatham for their retirements, and they sought to have a piece of the town for themselves and their families. As a result, real estate values climbed sky-high. The residential construction industry has had periods of explosive growth and relative stagnation, but land in Chatham will always be desirable. After all, no one is making any new waterfront property.

As they did 50 years ago, year-round residents have found creative ways to survive the seasonal economy, turning to fishing, shellfishing, or other jobs to make ends meet when the tourists and summer residents have all gone home. When it comes to making a living in Chatham, the secret is the same as it has always been—versatility.

In the 1960s, Chatham and other Cape Cod towns might have been accused of "rolling up the sidewalks" in the off-season. The winters were long and seemed longer still because there were only four or five television stations that came in clearly on the television set. Answering that need, "Chathamites" developed community groups, arts classes, and cultural and library activities. Others became involved in politics or charitable organizations. With First Night Chatham, the town simply threw a giant party to light up what can seem like one of the darkest, coldest nights of the year.

Actually, most of the town's landmarks look the same as they did a half-century ago. Aside from the new lantern room on top of Chatham Light, the Coast Guard station is mostly unchanged.

If one ignores the vintage automobiles, photographs from downtown Chatham in the 1960s look almost like they could have been taken last week. Thanks to the efforts of dedicated preservationists, many of the town's treasures survive in their previous glory, like the railroad depot, the Godfrey Mill, the Marconi wireless campus, and countless private homes and businesses.

Chatham's interest in its history is nothing new. Organizers of the year-long celebration of Chatham's 300th birthday in 2012 learned that their predecessors had thrown similarly elaborate parties in 1812, 1912, and 1962. Mimicking a beard-growing contest that was part of the 250th anniversary of the town's incorporation in 1962, the tercentenary planners offered citizens—men and women alike—fake beards they could stick to their chins for the 300th anniversary picture. It was testament that honoring history is not just building regulations, architectural surveys, and paint chips. It can also be a hoot.

Naturally, coastal erosion is not a new phenomenon; shifting sands are what give Chatham its shape, its waterways, and its beaches. What is new in the past 50 years is the proliferation of houses along the waterfront, and given the ocean's regular habit of rearranging the coastline, it is a recipe for conflict. Projected sea level increases will only intensify the problem.

Though coastal erosion is typically a slow process, it occasionally causes sudden changes, as it did in 1987 when the Atlantic punched a hole through Chatham's protective barrier beach. With property owners and regulators struggling to stem the damage, and with the nation watching on the evening news, Chatham houses began slipping into the surf.

Twenty years later, people flocked to the shoreline again when an unusual spring storm opened another inlet in North Beach. This time, the damage was mostly to the barrier beach itself and to the beloved family camps that stood there for generations. As the new inlet widened, the camps to the north either washed away or were torn down before the ocean could claim them. The camps to the south found themselves isolated on a shrinking island.

Though it brings heartache at times, nature is still what draws people to Chatham. Conservationists have worked for decades to preserve bits of untamed wilderness, even in this densely developed place. The largest tract, by far, is the Monomoy National Wildlife Refuge, taken by the federal government as a bird sanctuary and now one of the nation's most important refuges for migratory birds. Management of that land, as with the Cape Cod National Seashore, has involved much planning, politicking, bargaining, and litigating over the years. The Chatham Conservation Foundation has impressive holdings of its own, from majestic Strong Island in Pleasant Bay to secluded woodlands away from the coast.

Increasingly, visitors to Chatham are coming for the wildlife, from the birds on Monomoy to the seals in Chatham Harbor. In recent years, they have been coming to try and glimpse a great white shark, though they are admittedly much easier to see in Main Street gift shops than in the ocean.

The past 50 years have been transformative for Chatham in each of these ways. What has not changed, of course, is the ever-changing ocean.

One

SUMMER LIFE

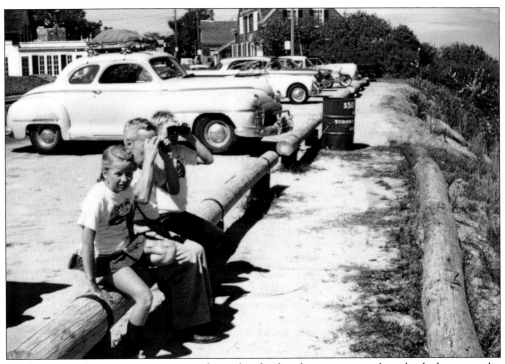

As they are today, summer visitors and people who live here year-round are both drawn to the lighthouse overlook to gaze at the Atlantic and the shifting sands of the barrier beach offshore. Joan Aucoin (seated, foreground) remembers visiting in 1958. (Courtesy of Joan Tacke Aucoin.)

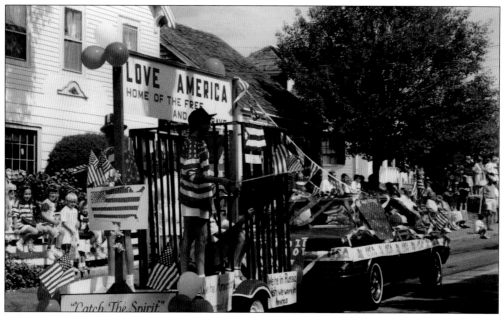

Independence Day parades have long been a staple of summertime in Chatham. The date of this photograph is not certain, but the Cold War was still being waged. The sign in front of the prison bars reads, "We're in Russia. Wish we were in America." (Courtesy of Nancy Whalen Rude.)

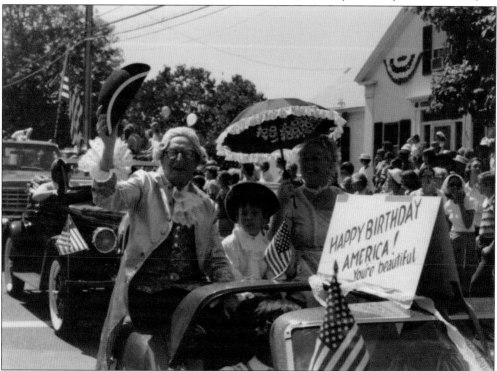

The Fourth of July was particularly festive in Chatham in 1976, thanks to the nation's bicentennial. The crowds on the sidelines were very enthusiastic, even if the boy in colonial garb was not. (Courtesy of Jane Powers.)

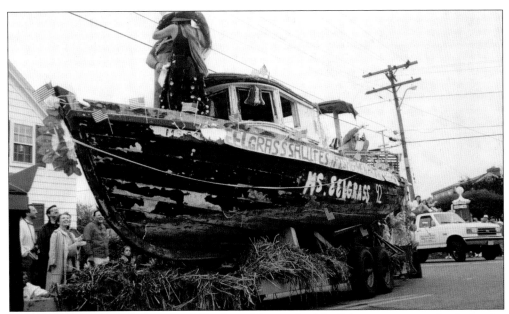

For more than a decade, a staple of Chatham life was the Ms. Eelgrass contest, a fundraiser for local children's charities. The contestant with the gaudiest fashion sense took the coveted title and was mate to Captain Eelgrass, local trap fisherman Paul Lucas. They are featured here in the 1992 Independence Day parade. (Courtesy of Nancy Whalen Rude.)

The Fourth of July parade passes in front of the Methodist church sometime during the 1960s. The picture was taken from the vicinity of what is now the Chatham branch of the Cape Cod Five Cents Savings Bank. A neon sign—which would make today's preservationists cringe—marked Webster's Sport Shop.

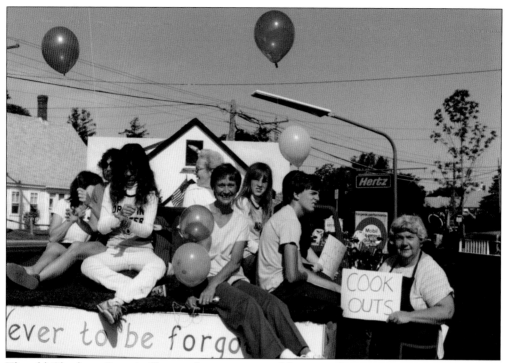

The old Chatham Drop-in Center, the precursor to Monomoy Community Services, provided activities and services for local teens, including cookouts and "rap sessions." On the right is one of the founders of the center, Dorothy Harned, with a group of teens trying—with mixed results—to look cool sitting on a parade float. The year is 1982. (Courtesy of Faith Twombly.)

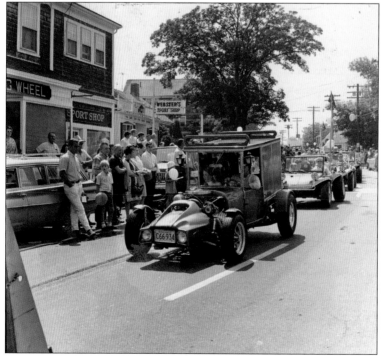

A procession of hot rods and dune buggies approaches the intersection of Main and Cross Streets sometime during the 1960s. The building on the left is gone, but it was once next to the stately Eldredge Public Library.

For 48 years, Whit Tileston, right, was the iconic conductor of the Chatham Town Band. Known as "Mr. Music," "The Man in the White Suit," or the "Hi-de-ho Man," Tileston developed the traditional Friday-night music programs. After the maestro's death in 1995, the town named the Kate Gould Park bandstand in his honor. Tileston was most likely wielding the baton when the photograph below was taken in 1976. The park looks a bit different than it did then, owing to the expansion of the Chatham Wayside Inn. (Below, courtesy of James J. Dempsey.)

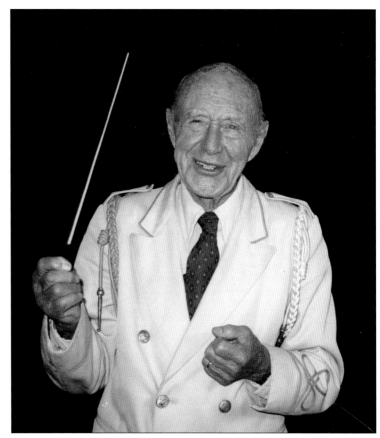

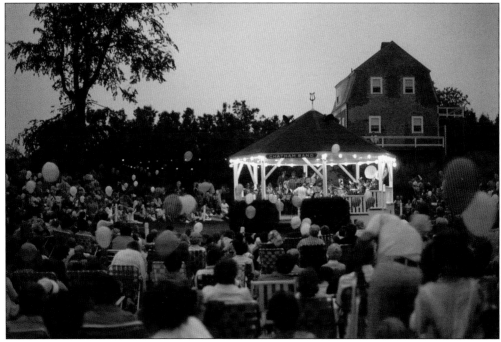

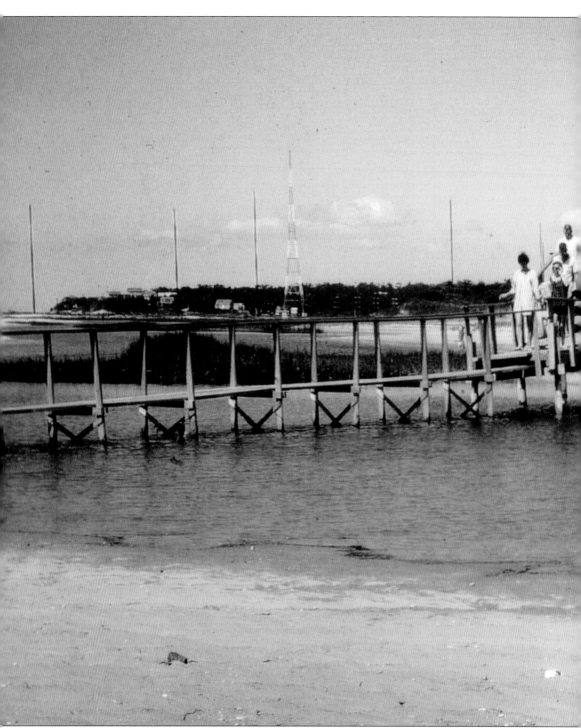

For many people, the downtown area and the Old Village represent Chatham. But like every other town on Cape Cod, Chatham is divided into villages, each with its own distinct identity. Many vacationers came year after year to cottage colonies in places like South Chatham and spent most of their time in their village. Here, beachgoers cross a footbridge to Cockle Cove and

Ridgevale Beach on Nantucket Sound. Though the sands have shifted somewhat, a more modern footbridge stands in the same area today. Visible in the distance are towers for the Marconi wireless transmitting station near Forest Beach. The towers are now gone, and the land is preserved by the town as open space. (Courtesy of M. Miklus.)

The view from the opposite side of the footbridge on the previous page shows how Cockle Cove Creek has shifted. For many years, Buck's Creek had a separate outlet to Nantucket Sound, apparently just visible in the background. On the bluff behind it is the Harding Shores development, which was relatively new at the time. (Courtesy of M. Miklus.)

A timeless summertime scene in Chatham involves the catboat. Built originally as sturdy, stable, near-shore fishing boats, catboats have become the classic wooden sailboat of choice for many Cape-sailing enthusiasts. This one is pictured off Cow Yard Landing at sunrise.

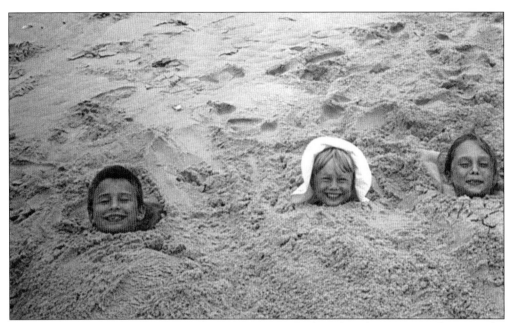

Sun and surf simply are not enough. Summertime in Chatham has always meant playing in the sand, as members of the Stone family were photographed doing in the late 1980s. (Courtesy of Jason and Martha Stone.)

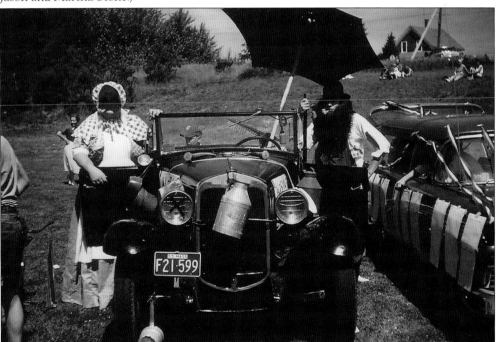

The first-place winner of the 1962 Independence Day parade was a float entitled "Alaska or Bust," featuring "Doc" Smith's 1930 Model A Ford. Lee Marden of Sears Point Road played the part of "Pa," and "Ma" was Peter Small, son of Mary and (selectman) Everett Small. The judges were particularly impressed at the six live borrowed chickens in the rumble seat. (Courtesy of Lee Marden.)

Chatham's beaches have always lured people in summertime. Beaches on the Nantucket Sound side have relatively warm water for swimming, and the water is even warmer in protected areas like Oyster Pond, pictured above in 1972. But to experience swimming in the Atlantic requires a trip to the east side of town. The barrier beach, known locally as North Beach but by others as Nauset Beach, used to run continuously south from Orleans to a spot opposite Morris Island. The postcard view below shows Lighthouse Beach in the foreground with the barrier beach in the distance. North Beach has since broken into pieces (see chapter 5) as part of a natural cycle of beach disintegration and regeneration. (Both, courtesy of Joan Tacke Aucoin.)

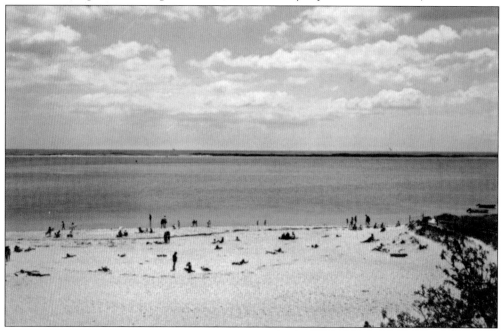

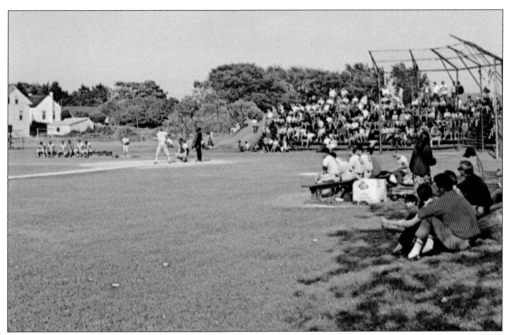

The Cape Cod Baseball League, a staple of summertime entertainment in Chatham, has been around in one form or another since 1885. Town teams competed in the early years, and by the 1960s, teams were made up by a combination of locals and regional college players. The Chatham Athletics were hot in the late 1960s, earning their first league championship in 1967, when Thurman Munson was a player. Fans came out in force for home games (above) and matches in other Cape towns, like Orleans (below). In 2008, in a dispute with Major League Baseball, "the A's" changed their name to the Chatham Anglers. (Above, courtesy of Joan Tacke Aucoin.)

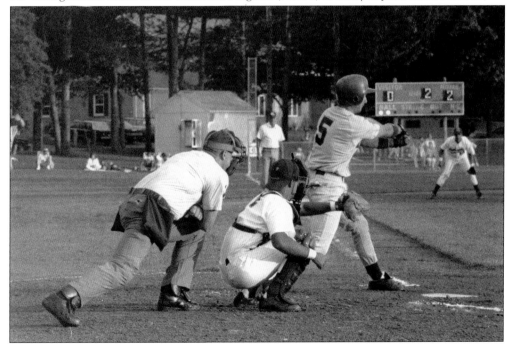

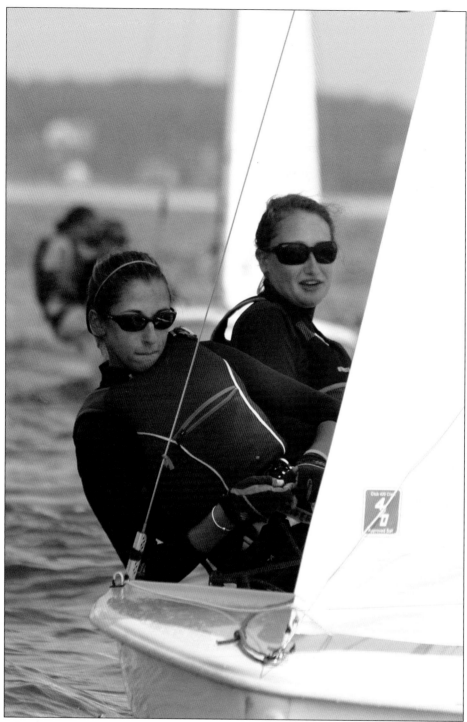

Stage Harbor Yacht Club, established in 1932, holds sailing classes for youngsters and annual regattas for sailors of various skill levels. In July 2008, the club hosted the Gill Trophy regatta, pitting young women from 31 teams representing more than a dozen different clubs. In addition to Stage Harbor Yacht Club, Chatham is home to the Monomoy Yacht Club and Chatham Yacht Club.

Pleasant Bay Community Boating was established in 2002 under the umbrella of the Chatham Marconi Maritime Center and became an independent organization the following year, offering affordable sailing classes for youngsters from Chatham, Harwich, Brewster, and Orleans. It also offers regular expeditions for kids in summer programs at Monomoy Community Services, like this one in July 2009.

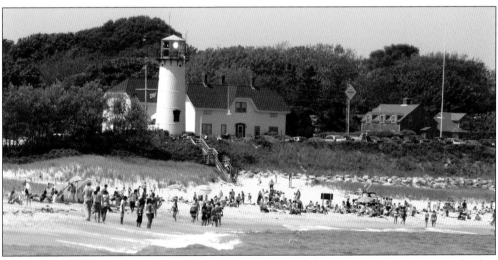

Chatham's most famous attraction in the summertime is Lighthouse Beach. For years, town leaders wrestled with whether to have lifeguards at the beach, which has swift currents and a steep drop-off. The latest concern comes from great white sharks, which hunt seals near the harbor entrance. So far, they have avoided the swimming area.

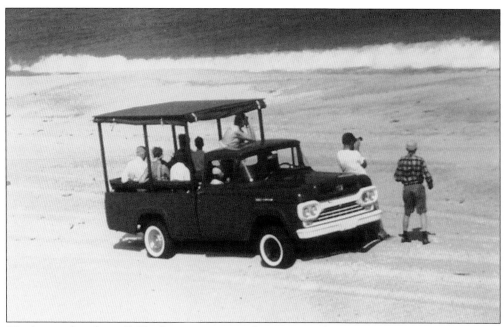

The barrier beaches off Chatham are a natural treasure and an important part of the town's cultural history. For years, the Massachusetts Audubon Society used a modified pickup truck to shuttle birdwatchers to areas on South Beach and Monomoy Island, as seen in the photograph above. Eventually, measures to protect threatened shorebirds like the piping plover limited vehicle access to the beach. But in the 1960s and 1970s, the outer beach was a popular destination for locals looking to party, to fish, or to simply escape the hubbub of the mainland. Dune buggies were popular, but even ordinary two-wheel drive vehicles were often brought on the sand by reducing the air pressure in the tires, as seen below.

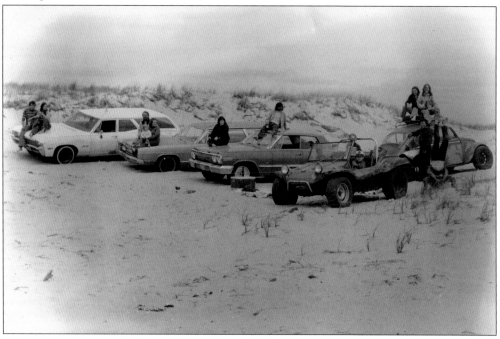

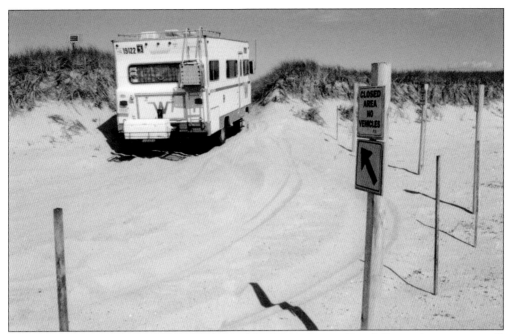

Off-road campers, many owned by members of the Massachusetts Beach Buggy Association, still frequent North Beach in the summertime. The Towns of Chatham and Orleans, with the support of the association, worked with state and federal regulators to allow continued vehicle access to the barrier beach in a way that safeguards nesting shorebirds.

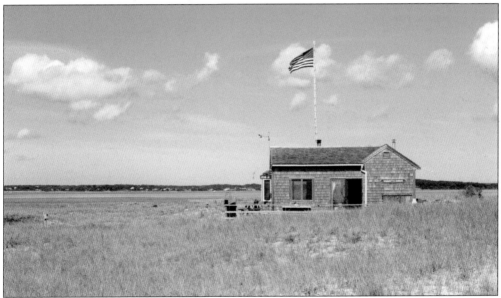

Hammatt's Hangar was located in one of two clusters of camps, known as the First Village and the Second Village, that once dotted the length of North Beach. Most of the camps are now gone (see chapter 5), but for generations, they were treasured getaways for local families. The camps on the barrier beach had their own social rules and customs, and camp owners typically spent as much time as possible there, even in the off-season. Their reward was solitude, incredible views of nature, and quiet, starlit nights.

In the late summer of 1972, there were relatively few houses on the shore of Oyster Pond, and many were single-story homes. Today, the houses in the photograph have all been vastly enlarged and crowded in by expensive luxury homes. (Courtesy of Joan Tacke Aucoin.)

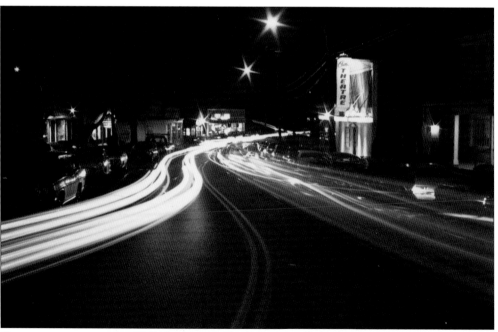

On a summer evening in 1976, downtown Chatham was a hub of activity even after dark, with patrons visiting various local restaurants and the Chatham Theatre, pictured at right. (Courtesy of James J. Dempsey.)

Two

THE YEAR-ROUND ECONOMY

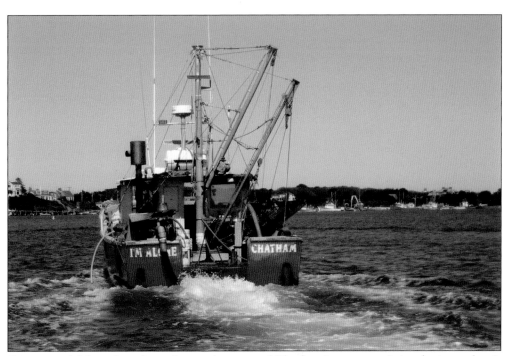

Commercial fishing has always been a key part of Chatham's economy. It is a business that is well suited to those who like solitude, as the name of this boat attests. Owing to the decline in groundfish stocks, the number of fishermen working from Aunt Lydia's Cove or Stage Harbor (pictured) decreased markedly in the late 1980s and early 1990s, but commercial fishing remains an important industry in town. (Courtesy of Nancy Whalen Rude.)

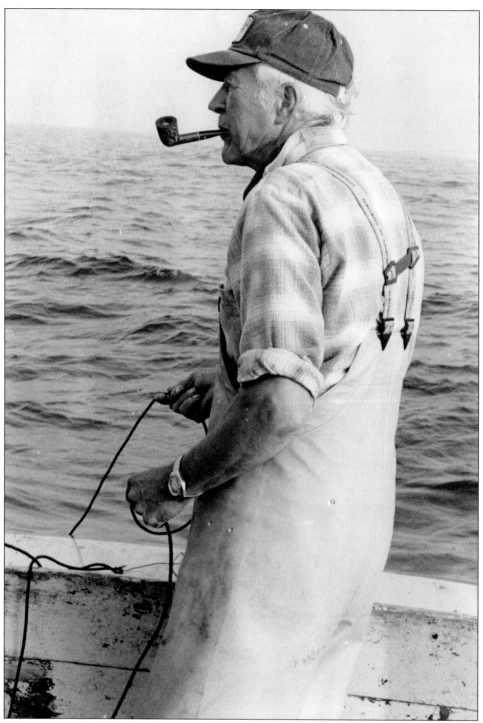

Unlike commercial fishermen from ports like Gloucester or New Bedford, Chatham fishermen have always worked on a small scale, fishing only a day or two at a time. Here, fisherman Bob Hyora jigs with a hand-line. Though today's fishermen have the benefit of modern equipment for navigation and fish finding, they still fish on a small, sustainable scale.

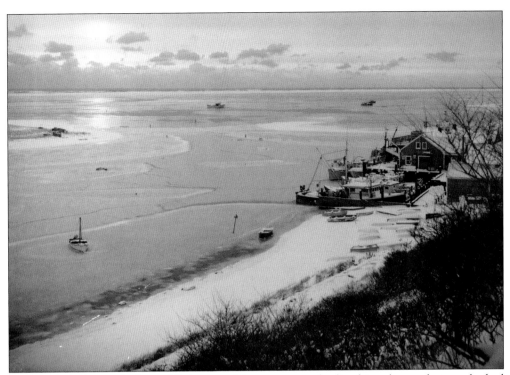

Aunt Lydia's Cove, which was likely named for a woman who lived in a house that overlooked the area, is home to the Chatham Fish Pier, pictured above. Owned by the town, the facility provides a place for the local fishing fleet to unload its catch, pack it in ice, and prepare it for shipping. Years ago, it was a modest facility; it now boasts additional dock space and a more modern packinghouse with a popular observation deck on top. The town's other important fishing harbor is Stage Harbor, below, which provides boats easy access to Nantucket Sound. (Above, courtesy of Barbara Stevenson; below, courtesy of Nancy Whalen Rude.)

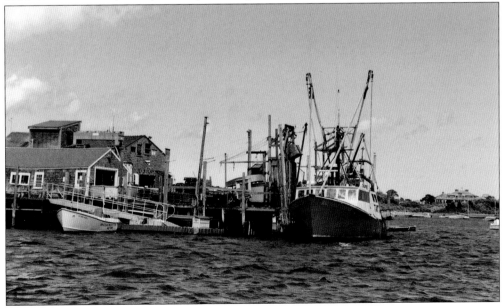

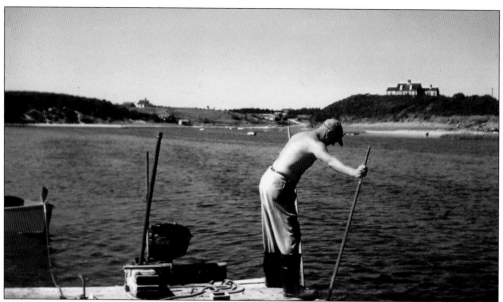

Not all the shellfish from Chatham waters come from wild fisheries. Oyster Pond is still home to the town's only inshore aquaculture operation, an oyster farm operated by the Chatham Shellfish Company since 1976. But given its name, it is not surprising that Oyster Pond has an even longer history with that tasty bivalve. Here, oysterman Des Eldredge works a grant in the Oyster River in 1953. Note the sparsity of houses on the shoreline. (Photograph by Shirley Tappan, courtesy of Scott Tappan.)

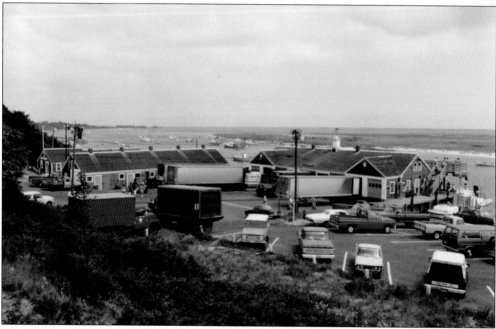

The Chatham Fish Pier was a hive of activity when cod and other groundfish species were plentiful. In 1978, a line of shanties stood just south of Nickerson Fish and Lobster, providing space for local fishermen to process their catch, bait their gear, or stow equipment. (Courtesy of Frances Nickerson and Phyllis Nickerson Power.)

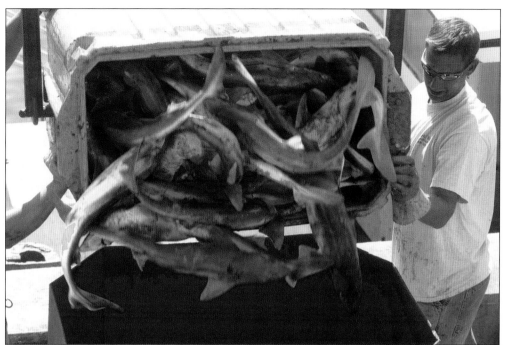

Once referred to as "trash fish," spiny dogfish became a marketable species when cod and other commercially important species began to decline. A member of the shark family, they now represent a sizable portion of the catch from local day boats. Here, fishermen unload their catch of "dogs" at the Chatham Fish Pier in 2003.

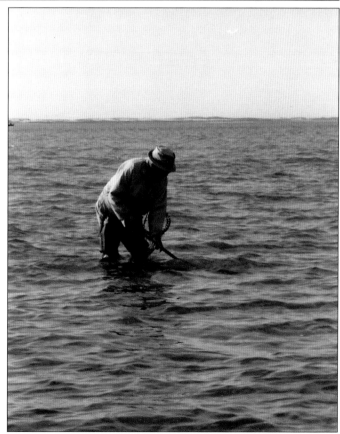

Well-known oysterman Clint Hammond sold Chatham oysters to clients as far away as Boston. He came by his love for the water naturally; his father was John William Hammond, master of the steamship *Susquehanna*. (Courtesy of Helen Tedford and Bill Jamieson.)

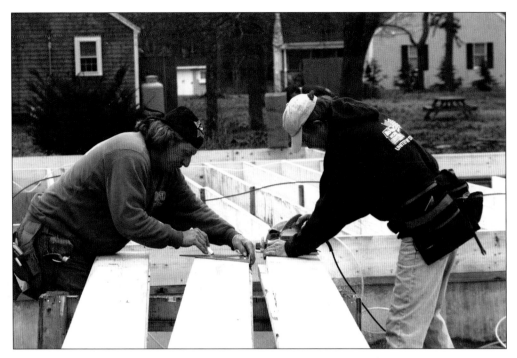

Chatham experienced a building boom in the 1950s and 1960s, with one of the largest residential subdivisions, Riverbay Estates, opening in 1962. Another surge in development happened in the late 1980s and early 1990s, but new construction continues today at a steady pace. Pictured above is a crew working on a new house in 2005. The aerial photograph below of Mill Pond and Little Mill Pond from the early 1980s shows that most waterfront parcels already hosted large homes. (Below, courtesy of Jason and Martha Stone.)

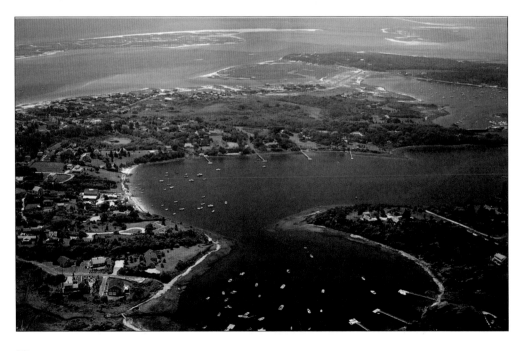

Chatham no longer has a lumberyard of its own, but that was not true years ago. In addition to Airport Lumber, which occupied the site on George Ryder Road where the police station and town offices annex now stand, there was Nickerson Lumber Company on Depot Road, pictured at right. Note the community building on the far right, which was recently removed to make room for the town's new fire station. The building trade was vigorous in the 1970s and 1980s. Below, carpenters work on a house on Training Field Road in 2003. (Right, courtesy of Norma M. Kendrick; below, courtesy of Nancy Whalen Rude.)

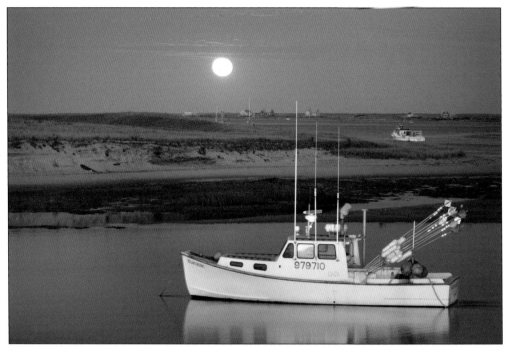

The last 50 years have seen a complete transformation of the commercial fishing industry, which started as a little-regulated, low-tech business. Overfishing, possibly exacerbated by climate change, caused the decline of codfish and other species. It remains an important industry in Chatham, and one of the most dangerous occupations around. Above, the *William Gregory* swings at its mooring in Aunt Lydia's Cove. Below, the crew of the *F/V Sand Dollar* unloads its catch of halibut around 1975. (Below, courtesy of Pat Ford.)

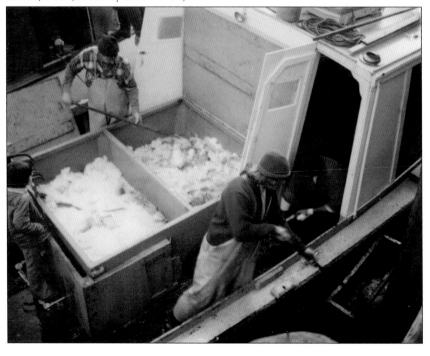

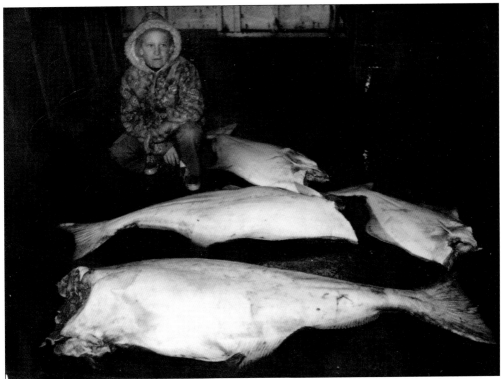

Commercial fishing was not the exclusive domain of men. Priscilla "Pat" Ford hand-lined for halibut and landed the record-setting haul seen above sometime in the 1970s. The fishing industry includes a number of shore-side businesses that once included the Old Harbor Fish Market and Lobster Pool on Main Street, pictured below. The fish market was razed and replaced by condominiums. (Both, courtesy of Pat Ford.)

This imposing building on the shore of Stage Harbor is no more. Old Mill Boat Yard stood on land now occupied by the town parking lot at Stage Harbor. The boat ramp on the left is adjacent to the harbormaster's office.

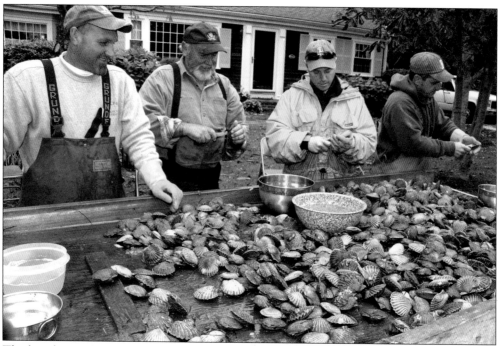

The best harvest of bay scallops in decades happened in 2009. Here, from left to right, Andy Blanco, Dick Fulcher, Dave Garre Jr., and Erik Fulcher hold a shucking party.

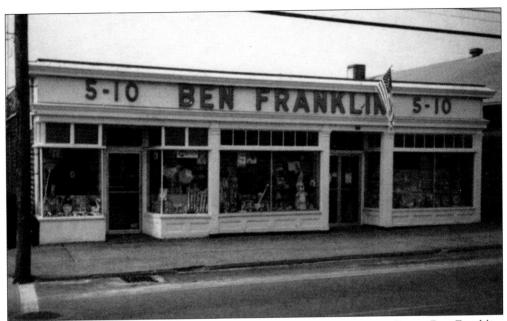

Though many downtown shops close for the winter, a few remain open. One is Ben Franklin, Chatham's five-and-ten store, which started as Webster's Five-and-Ten. The store has been renovated with more classic architecture and no longer bears the big red letters spelling its name.

For many years, Chatham was a commercial hub for the Lower Cape, and it had its own doctors and other professionals. This house at 720 Main Street was the residence and office of the town dentist, Dr. George R. Smith, whose son Preston Smith, DDS, practiced there for many years. The house was torn down, and the current building was erected in its place in 1971. (Courtesy of Norma M. Kendrick.)

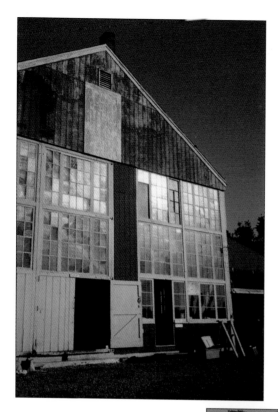

The late afternoon sun is reflected in the windows of Pease Boat Works, which specializes in building and restoring wooden boats. The boatyard was built by famed naval architect F. Spaulding Dunbar, and master boatwrights still labor here at the edge of Mill Pond, using time-tested designs. (Courtesy of Nancy Whalen Rude.)

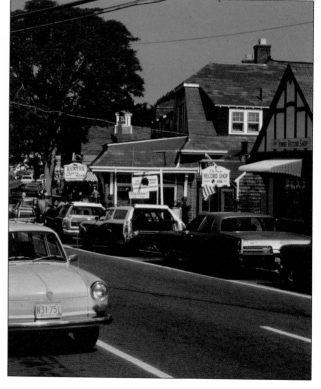

Even in the 1960s and 1970s, downtown Chatham was a popular spot for window shoppers. While the buildings largely remain, some of the businesses pictured are long gone, including Hunter Sportswear, the Towne Record Shop, and the Indian Craft Shop. (Courtesy of Roger Denk.)

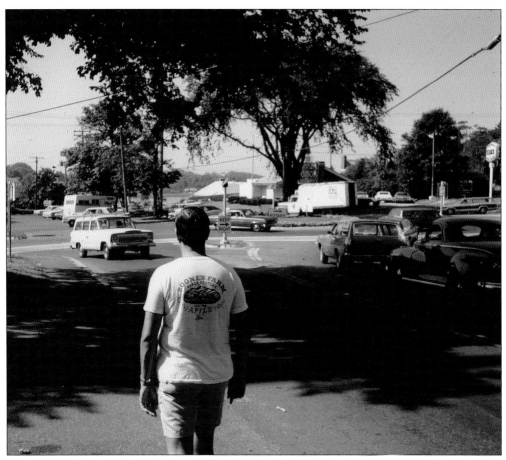

The Chatham Rotary is a place to avoid in the summertime today, and traffic was not much lighter in 1969. Visible is the edge of the old Texaco gas station and the long-lost Howard Johnson's restaurant, which has since become a public park. In 2015, local organizers raised funds to erect the town's only World War II memorial there. (Courtesy of Roger Denk.)

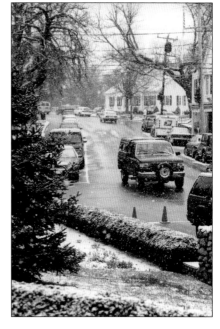

Many retailers in downtown Chatham stay open through the fall to take advantage of the Christmas shopping season. Pictured is a snowy downtown scene from the late 1990s. Even today, the area becomes considerably quieter after the New Year, with many businesses staying dormant until shortly before Memorial Day.

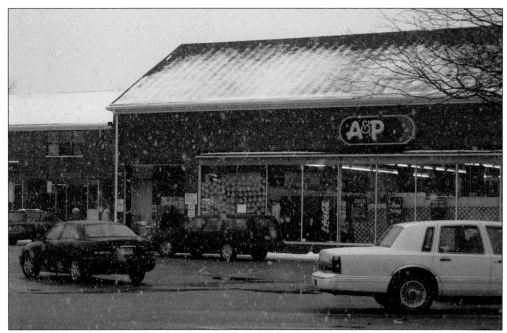

Chatham has had many small supermarkets over the years and at one point had two A&P stores. One was in West Chatham, at the site of the current Ocean State Job Lot, and the other, seen above, was at the intersection of Main Street and Queen Anne Road. When A&P decided to sell the store in 2003, a group of former employees purchased it, and they were strongly supported by residents who did not want to lose the town's last remaining grocery store. They operated the Chatham Village Market in the old A&P space for years and opened a newly renovated store, pictured below, on the same site in May 2011 to much fanfare.

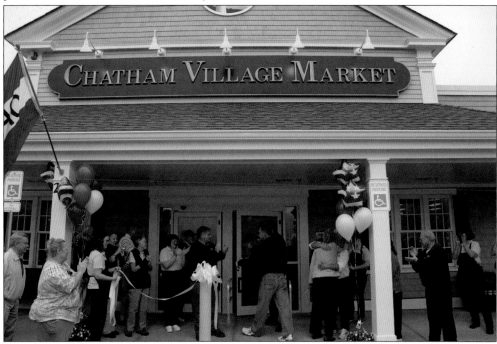

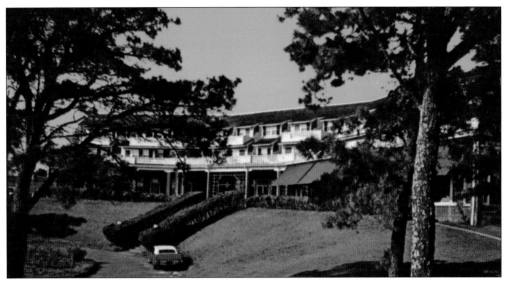

Once home to several grand hotels, Chatham now hosts only one: Chatham Bars Inn. The inn's main building looks much as it did in this 1960s-era postcard, which is not very different from the way it looked when it opened in 1914. In 2014, the inn marked its centennial with various parties and a Gatsby-themed costume ball. (Courtesy of Joan Tacke Aucoin.)

The Bradford Inn on Cross Street was a popular venue for years; it was owned by Audrey and Bill Gray from 1975 to 1998 and is pictured here in the early 1990s. It was recently converted to residences. (Courtesy of Audrey and Bill Gray.)

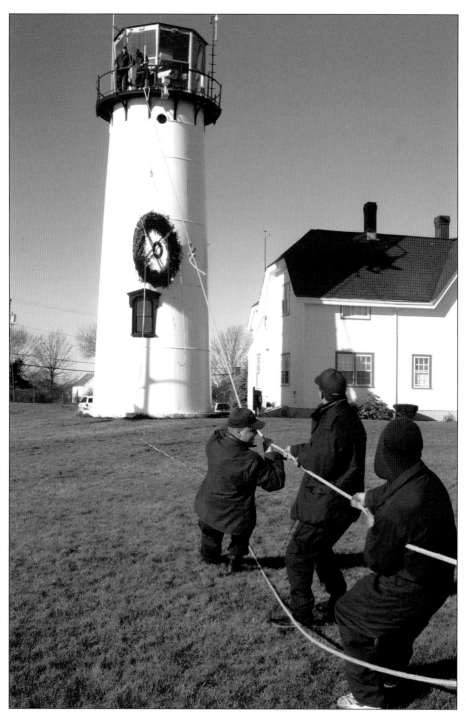

Surviving the off-season in Chatham is often a matter of versatility and teamwork. Each year, the crew of professional lifesavers at Coast Guard Station Chatham provide an emblem of that spirit when they hoist the wreath to its place on Chatham Light. Decorated with a life ring and oars, the wreath is reminiscent of the seal of the old US Lifesaving Service, the predecessor of the modern Coast Guard.

Three

CULTURE AND COMMUNITY

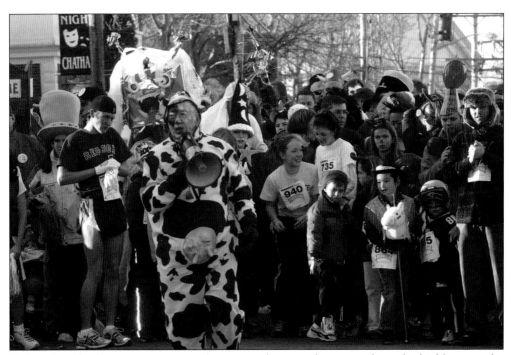

Culturally, Chatham is a spectrum of groups and events that range from the highbrow to the zany. In the latter category is the Carnival Caper Road Race, part of annual First Night Chatham celebration. Wrangling the runners into place, dressed like a cow, is the late organizer Richard "Dick" Sullivan. Sullivan was active in many worthy organizations like the March of Dimes and the Cape Cod Baseball League.

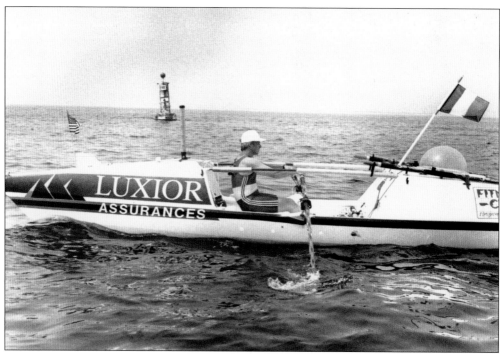

In the past 50 years, Chatham has been the jumping-off point for a dozen or more adventurers seeking to row across the Atlantic Ocean to Europe. About a half-dozen have made it, starting with Gerard D'aboville in 1980, but Jean Lukes, seen above, was not among them. Lukes attempted crossings in 1994, 1995, 2001, and 2004 but never lasted more than 15 days at sea. Emmanuel Coindre, pictured below, tried three times and succeeded twice; he still holds the solo record for making the passage in 62 days.

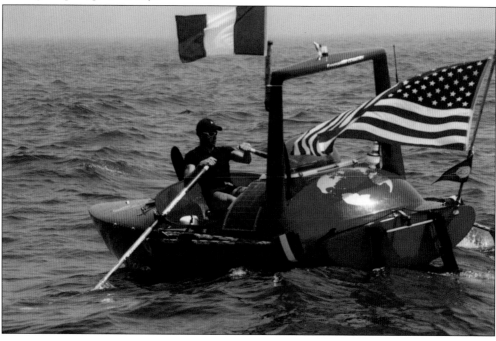

Ocean rowing is an incredibly risky sport. In 2001, sixty-two-year-old Chicago cardiologist Nenad Belic, pictured here, rowed away from Chatham. He rowed for more than four months and was last seen alive by the crew of a passing freighter. Before he departed Chatham, Belic acknowledged the possibility of being lost at sea. Asked why he would attempt the risky passage, he replied, "It is a question to which there is no answer."

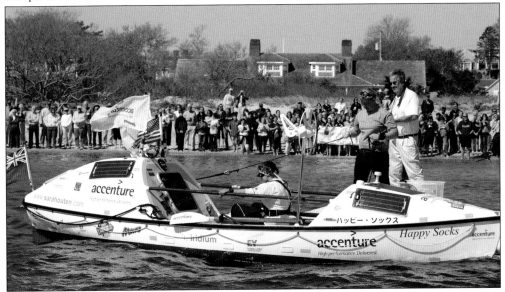

By modern standards, Belic's boat was primitive in its design and equipment. In 2015, a much younger rower, Sarah Outen, departed Chatham and remained at sea for 143 days before a hurricane forced her to abandon the crossing. Outen had a special distinction, though; her journey was part of a solo human-powered trip around the globe that included rowing the Atlantic and Pacific and biking across three continents.

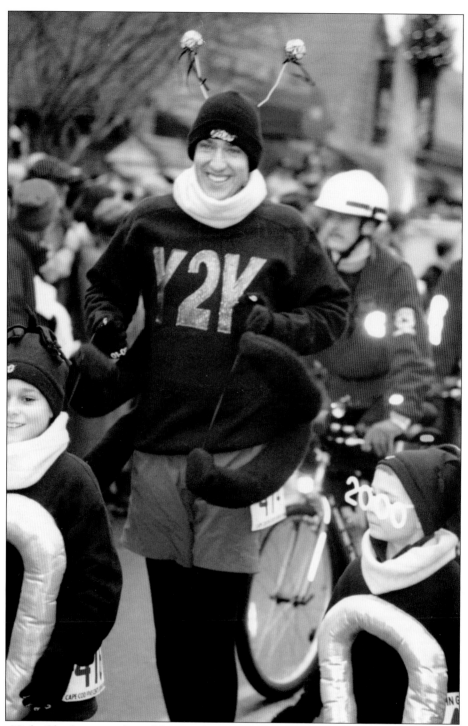

First Night Chatham, another of the town's signature events, first took place in 1991. A family-friendly New Year's Eve party, First Night Chatham features musicians and other performers from around the region. In Chatham, it is coupled with an annual costumed road race. In 1999, one of the runners in First Night Chatham's Carnival Caper Road Race was, of course, the "Y2K bug."

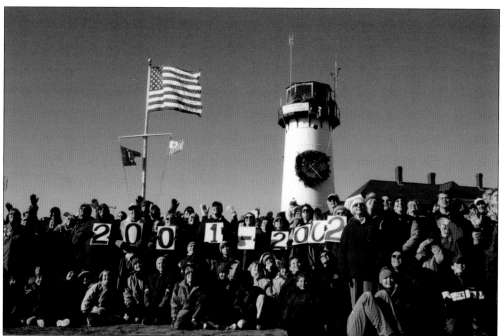

Chatham's unique sense of community is on display each December 31 at noon, when townspeople gather at the lighthouse for the town photograph, as seen above in 2001. The photograph kicks off First Night Chatham, a celebration of music and the arts at various downtown venues. At the 2015–2016 First Night, Chatham's group celebrated its 25th anniversary with more than 70 performance events. The event concludes each year with fireworks, a bonfire, and the dropping of Countdown Cod, a sparkling, illuminated likeness of a codfish.

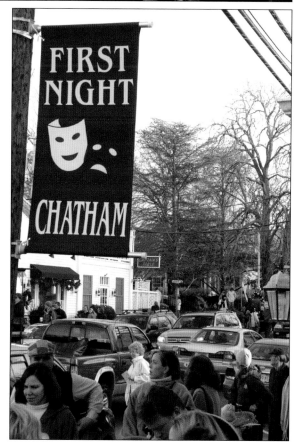

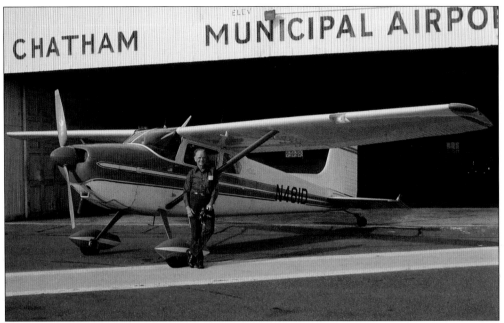

One of Chatham's legendary locals was the late Dick Kelsey, a talented photographer who took to the skies and became well known for his aerial photographs. His pictures and those of his protégé, Spencer Kennard, are still sold at their gallery in downtown Chatham. Their base of operations is the Chatham Municipal Airport. Built by aviator Wilfred Berube in 1937, the airport remains popular with private pilots and offers sightseeing and charter flights. In the early days, the airport lacked paved taxiways or tie-down areas and featured facilities for sea planes on adjacent White Pond, visible in the upper right of the image below. The area is now a residential neighborhood. (Above, courtesy of James J. Dempsey; below, courtesy of Tim Howard.)

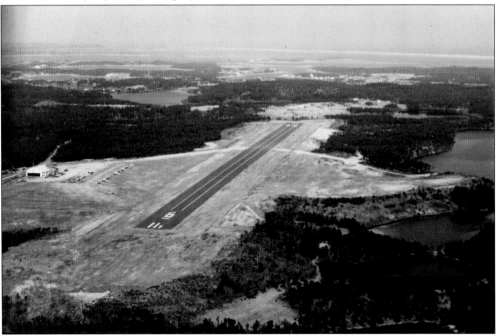

For years, volunteers, including Otis Russell (left) and Tim Wood (right), raised more than $450,000 for local children's charities through the Art of Charity, a gala auction of artwork donated by local professionals and amateurs. Known for offbeat antics and exciting bidding wars, the auction took place for 11 years, coming back for a last hurrah in 2012 as part of Chatham's 300th anniversary.

Another long-standing summer event that benefits Chatham's youngsters is the Taste of Chatham, which raises funds for Monomoy Community Services. Restaurateurs and purveyors of food and libations volunteer to serve up samples of their finest dishes for event patrons. Pictured is a scene from the 2007 event.

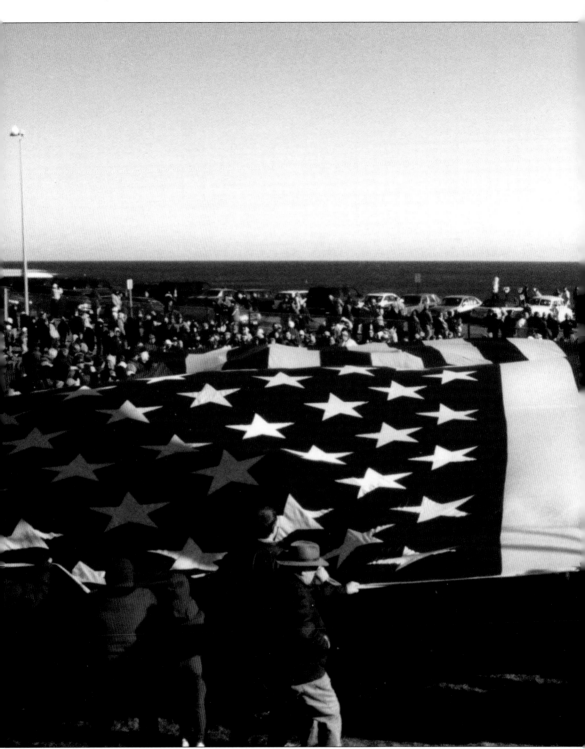

On December 31, 2001, with the nation still reeling from the 9/11 terrorist attacks, Chatham hosted three giant American flags, which were unfurled on the lawn of the Coast Guard station and held by Chathamites for the town photograph. The 90-foot-long flags, brought by the National

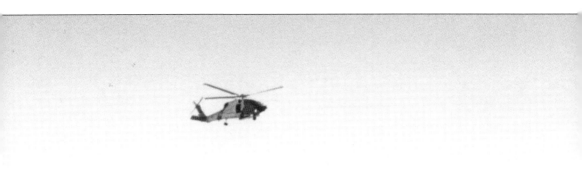

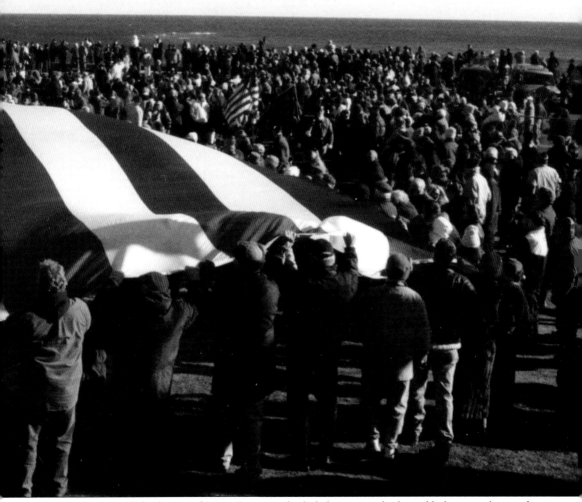

Flag Truck, covered the lawn and Main Street to the lighthouse overlook, and helicopters hovered overhead to take pictures of the display.

Chatham has long been culturally rich with music, dance, and theater. Valerie Buck of the Chatham Ballet and Dance Arts Center taught scores of locals the art of dance. In 1976, the center's dancers showed off their skills in a special demonstration in front of the windmill at Chase Park. (Both, courtesy of Pat Ford.)

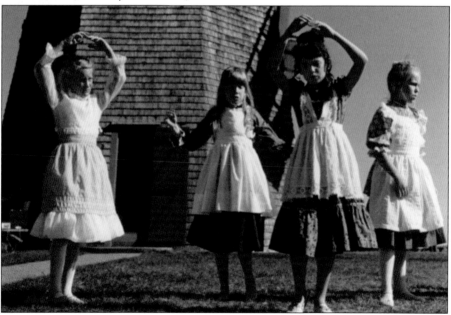

Chase Park is home to the town's biggest arts event, the long-standing annual Festival of the Arts. The Creative Arts Center, founded in 1969, established the festival a short time later, and it continues to draw large crowds of art patrons looking to view and purchase paintings, prints, sculptures, and other objets d'art.

In 2014, the Ms. Eelgrass Contest returned for a special encore performance after a 20-year hiatus. Captain Eelgrass, fisherman Paul Lucas, selected a mate from among a bevy of wacky suitors with names like "Scallop O'Hara" and "Ms. Peekin' Beacon." The event raised money for the Chatham Children's Fund.

Chatham loves its kids. Each Halloween, Chatham Elementary School students dress up in costume, as pictured at left, and parade downtown, stopping at stores and restaurants to get treats. Across the street from the school was the Robert Leathers playground, an elaborate wooden castle built by volunteers. It stood for 17 years before it was demolished in 2008, seen below, because of fears that toxic chemicals were leaching from the treated lumber. It was replaced by a more modern playground given by an anonymous donor.

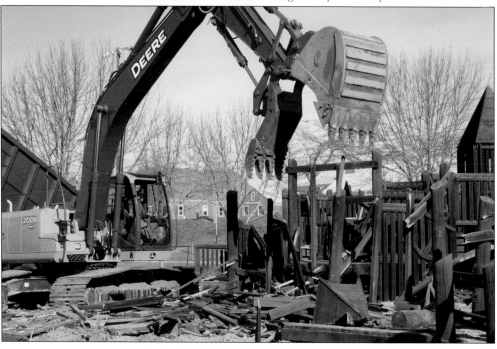

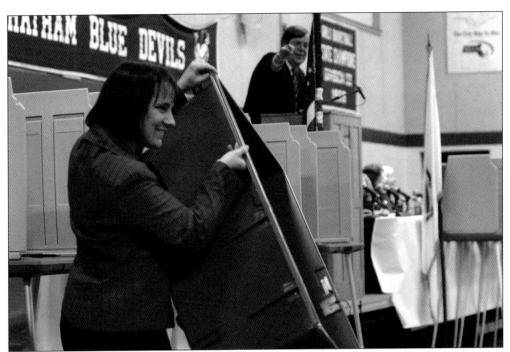

An important moment in Chatham's history came on the evening of December 6, 2010, when voters at a special town meeting authorized the merger of the town's school system with Harwich's schools, creating the Monomoy Regional School District. Votes were cast by ballot, and Town Clerk Julie Smith, seen above, showed the crowd the empty ballot container before beginning the count. The measure passed in Chatham by just 61 votes. Below, in 2013, elementary students from both towns signed their names on a beam that became part of the new Monomoy Regional High School.

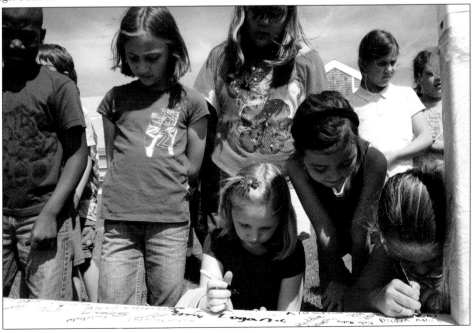

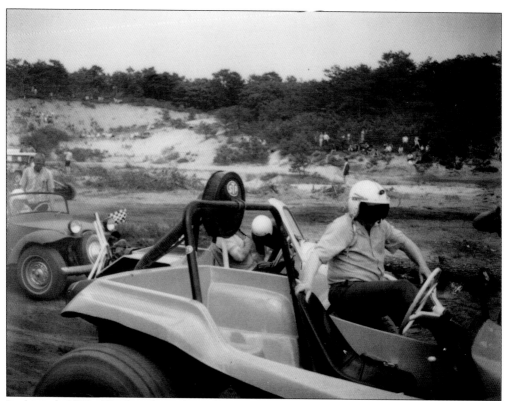

In the early 1970s, Chatham hosted popular dune buggy races. Held in a sand pit off Middle Road, the races sometimes drew hundreds of spectators, some of whom sat on the high bluffs around the pit. A few of the vehicles in the race were sophisticated, custom-built buggies designed for speed, and others were notably less showy. The Chatham Dune Buggy Association hosted the races, often on Sunday afternoons. (Both, courtesy of Pat Ford.)

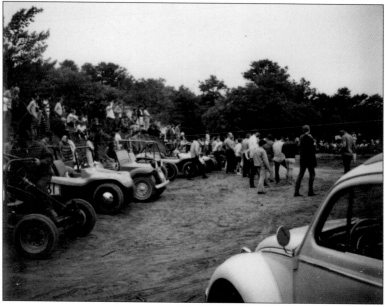

Four

PRESERVING HISTORY

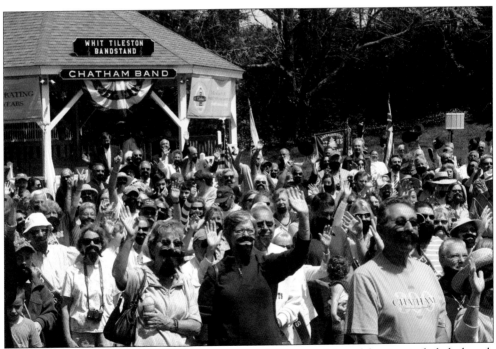

When Chatham celebrated its 250th anniversary in 1962, part of the celebration included a beard-growing contest, raising money for charity. The tercentennial in 2012 featured no such contest, but at the Founders Weekend celebration, volunteers passed out hundreds of fake beards, which residents—men and women alike—donned for a group photograph.

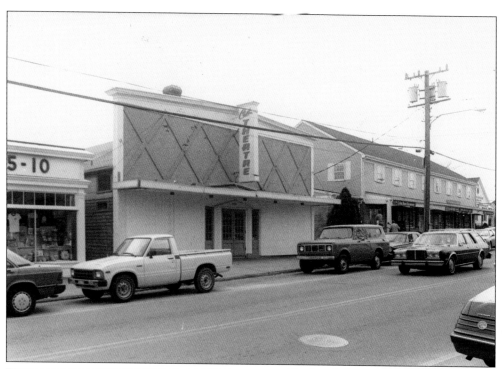

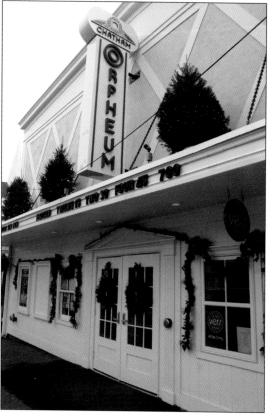

Chatham's first and only movie house, the Orpheum Theater, opened in 1916. It operated as Chatham Theatre between 1938 and 1987, when its owner, Interstate Theaters, closed the doors. It hosted live acts for a couple of years, including famous performers like Ray Charles, before it was converted to a CVS drugstore. In 2011, a group of volunteers created a nonprofit organization to purchase the building and restore it. Two years later, thanks to generous public support, the sparkling new cinema, pictured at left, opened with two screens and state-of-the-art projection and audio systems.

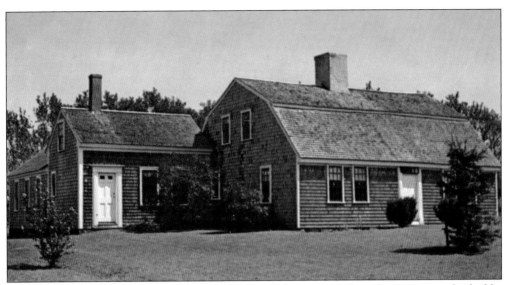

The collection of the Chatham Historical Society includes many artifacts that are rare and valuable, but perhaps none more so than the organization's headquarters itself: the Joseph Atwood House. The c. 1756 house was acquired by historians in the 1920s and operates as a museum. In 2009, an ambitious restoration and expansion was completed, leaving the building even larger and more impressive than in this undated postcard view. (Courtesy of Joan Tacke Aucoin.)

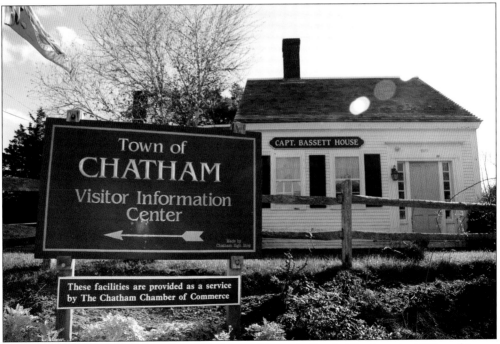

The town purchased the Capt. David T. Bassett House in South Chatham in 1986, seeking to preserve the historic half-Cape, which overlooks a gateway to town at the intersection of Main Street and Route 137. In 1997, using volunteer labor and funds raised by the group Count Me In, the house was renovated for its current purpose: the Chatham Chamber of Commerce's offices and visitor center.

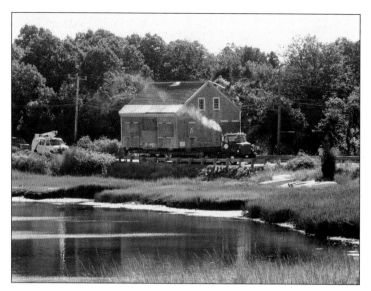

Using public Community Preservation Act funds and contributions from the Nickerson Family Association, the 1772 Caleb Nickerson House dodged the wrecking ball in 2003. It was trucked down the narrow roads of Nickerson Neck and then gingerly shuttled by barge to Ryder's Cove to its new home on Orleans Road in Chathamport. It is now fully restored and open to the public.

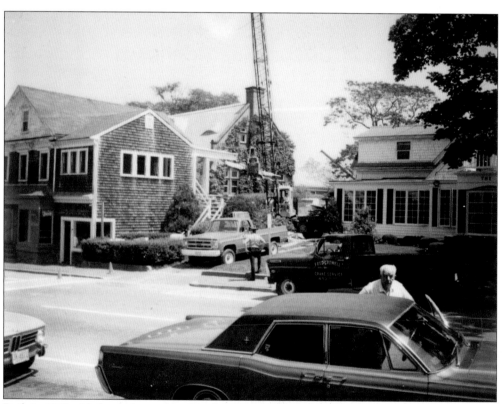

Built in 1896 with funds donated by Chatham native Marcellus Eldredge, who owned a profitable brewery in New Hampshire, the Eldredge Public Library has been a center of life in Chatham. In 1968, the library underwent a small expansion, pictured here. A larger addition and renovation took place in 1992. The library is seen behind a commercial building on the left, which is no longer there. On the right is Chatham's branch of the Cape Cod Five Cents Saving Bank. (Courtesy of Pat Ford.)

Many of the town's most significant works of preservation are carried out by enthusiastic property owners. The 1863 Port Royal House at 606 Main Street is among a host of local homes in the National Register of Historic Places. It overlooks Sears Park, the town's Civil War memorial.

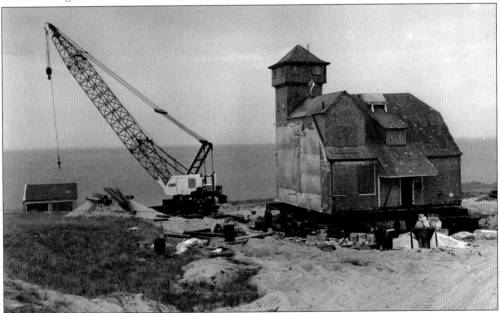

Built in 1898, the Old Harbor Lifesaving Station was one of 13 stations on the outer beach where rescuers kept watch for shipwrecks. Located on North Beach opposite North Chatham, the decommissioned building became a private summer retreat until the National Park Service acquired it in 1974. Federal preservationists split the building in two in 1978 and floated it by barge to Race Point in Provincetown, where it is back on the outer beach, as a museum.

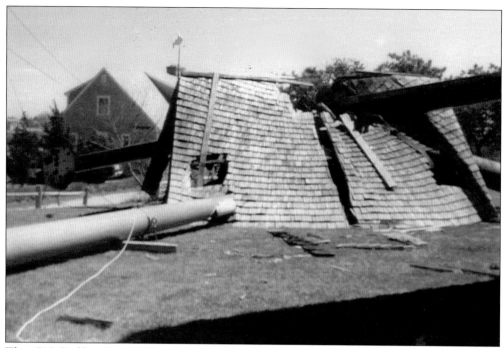

The 1797 Godfrey Grist Mill was acquired by the town in 1954 and moved to Chase Park, in need of serious restoration. The work was done, and the mill was opened to the public with much fanfare. Aside from a few glitches—like the time when a crane toppled while lifting the cap, above—preservationists have kept the windmill in good shape. Other renovations took place in 1989 and 2012; the latter date to coincide with the town's 300th birthday. (Above, courtesy of Norma M. Kendrick.)

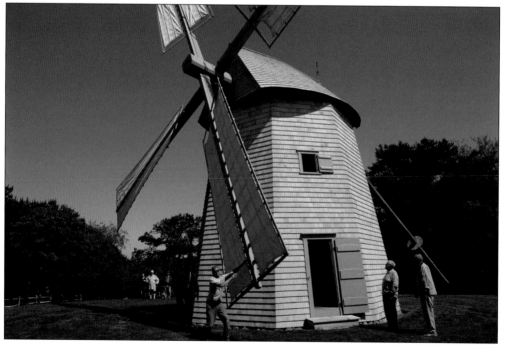

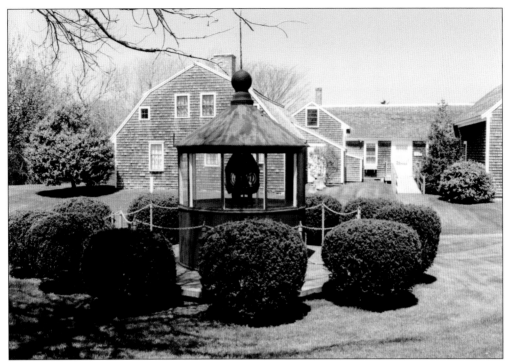

Today, the top of Chatham Light has a large lantern, installed in 1969 to accommodate a new 2.8-million candlepower beacon. Before that time, the lighthouse had a Fresnel lamp that was housed in a much smaller lantern, and in 1974, the old lantern was put on display outside the Chatham Historical Society's Atwood House Museum. Just out of view on the right side of the photograph above is the historical society's mural barn, which features the acclaimed murals of Alice Stallknecht, seen below. The central piece, "Christ Preaching to the Multitude," depicts Christ as a local fisherman in a dory.

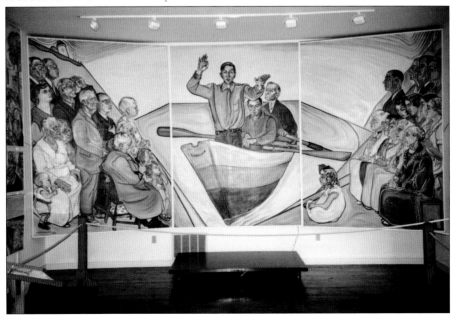

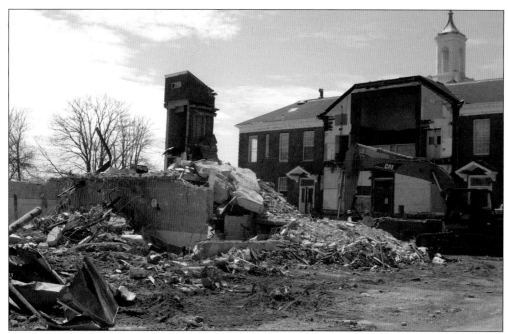

In 2006, the rear portion of the Main Street School was torn down to make way for the current community center. The town struggled for many years before deciding on the community center as a way to preserve and reuse the property. Generations of Chathamites passed through the school, which was built in 1924.

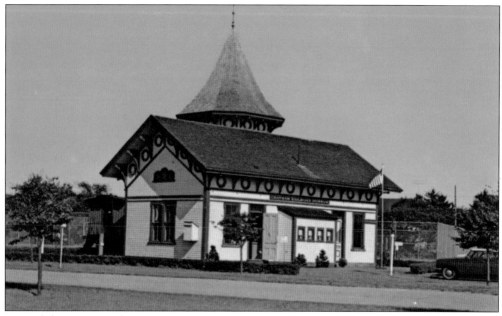

One of the town's earlier preservation projects was the railroad depot, now the home of the Chatham Railroad Museum. The museum was founded in 1960 and, as seen in this undated postcard view, features a 1910 New York Central wooden caboose out back. Under the leadership of volunteers, including the late Larry Larned, the museum underwent a complete exterior renovation in 2009.

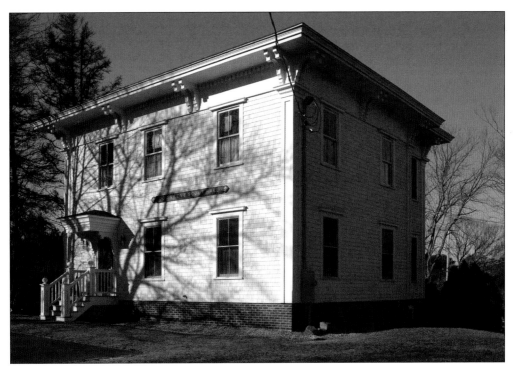

As with the railroad museum, Community Preservation Act funds were used to renovate the historic Atwood School on Stage Harbor Road. Better known as the Doc Keene Scout Hall, the structure was built as a grammar school in 1839 and is now home to Boy Scout Troop 71. Public funds helped preserve the building and make improvements that allowed it to continue in public use.

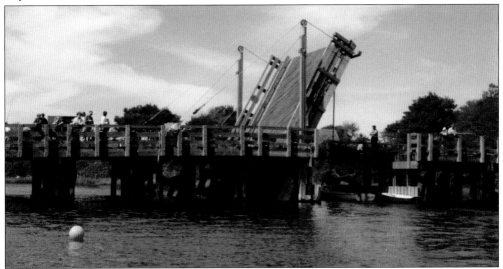

The Mitchell River wooden drawbridge is, alas, no more. Believed to be the last remaining timber drawbridge in the country, the structure was demolished and replaced with a more modern bridge in 2015 and 2016. Because its unique design kept the bridge from opening fully, boats with masts often passed through with only inches to spare; motorists remember the washboard effect of driving over the worn deck timbers. (Courtesy of Nancy Whalen Rude.)

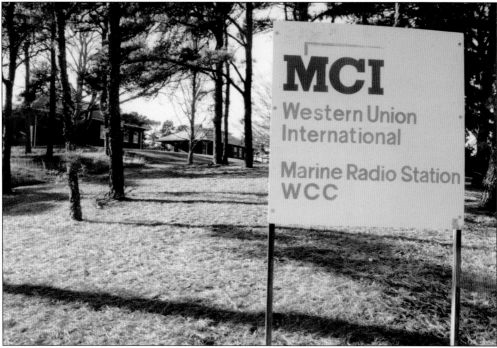

One of the town's triumphs of preservation happened in 1999, when taxpayers purchased the 13-acre former Marconi wireless campus from MCI. Transmitting from separate towers in South Chatham, Station WCC's ship-to-shore receivers were in Chathamport, seen above. In March 1999, after several tries, the 300-foot steel tower at the site near Forest Beach was toppled by a demolition expert, as pictured below. The marsh where the tower once resided is now conservation land, but the concrete footings for the tower remain. (Below, courtesy of Jim and Maraide Sullivan.)

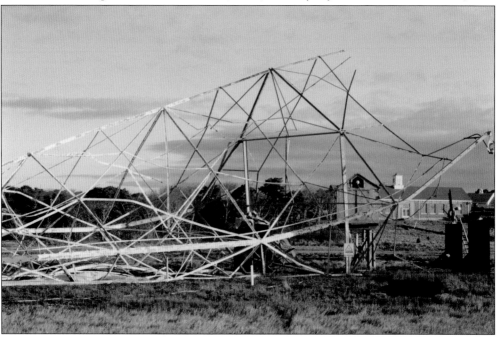

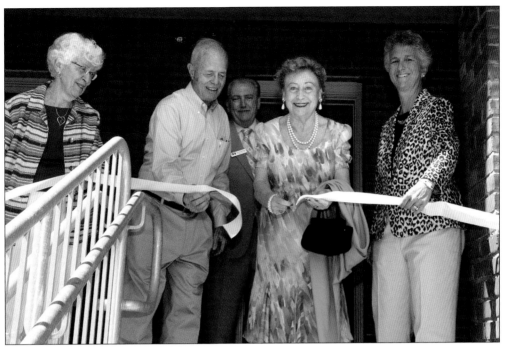

The Marconi campus in Chathamport is now occupied by the Chatham Marconi Maritime Center, which opened a museum in the renovated operations building in 2010. Above, Princess Elettra Marconi, daughter of wireless pioneer Guglielmo Marconi, snips the ceremonial ribbon to open the group's new education center in 2014. Still standing are the steel towers that helped make up WCC's antenna field, as pictured right.

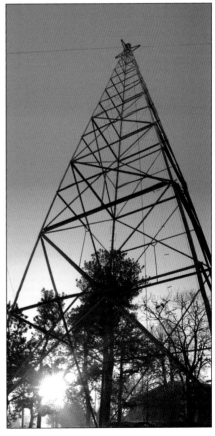

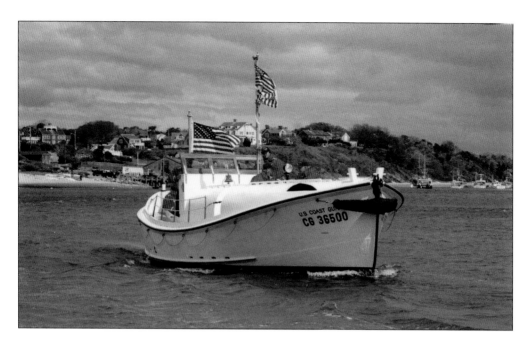

In 1952, crews from Station Chatham executed the most famous small-boat rescue in Coast Guard history, rescuing 32 men from the stern section of the tanker *Pendleton* in a blizzard. The rescue boat they used, the CG 36500, is preserved as a floating museum by the Orleans Historical Society, but it makes regular visits to Chatham, as seen above. In 2014, film crews visited Chatham to shoot scenes for the Disney feature film *The Finest Hours*. A replica of the CG 36500 edged its way through mock fog in Stage Harbor, with modern luxury homes just out of the camera's view.

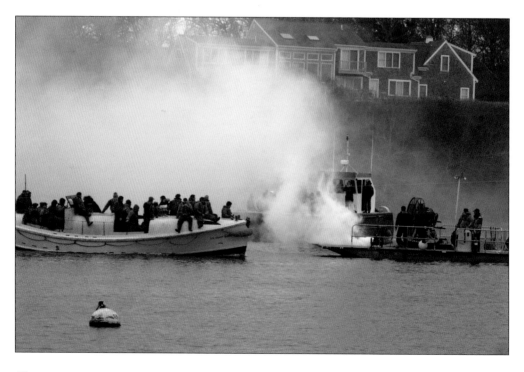

Five

WIND AND WAVES

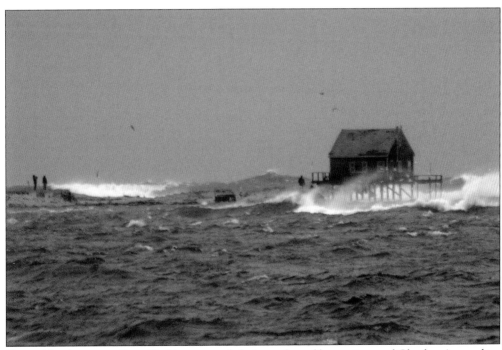

Created by glaciation, Cape Cod is constantly being reshaped by erosion, and Chatham's coastline is particularly dynamic. In January 2008, a fierce coastal storm generated tall ocean waves that battered North Beach, with the surf seeming to tower over the dunes on the barrier beach. With bystanders watching from the dunes nearby, the Truelove camp was undermined by the waves and would have to be torn down shortly thereafter.

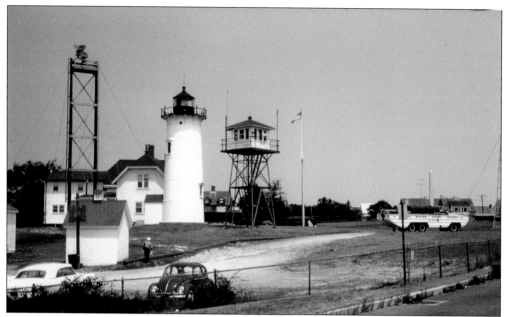

In 1961, the lighthouse and the rest of Coast Guard Station Chatham looked different than it does today. Note the small black lantern on top of the lighthouse and the lookout tower that has since been removed. On the front lawn is an amphibious DUKW, or Duck, boat, most likely a surplus item from World War II, that has been converted to a Coast Guard rescue boat. (Courtesy of Melissa Kraycir.)

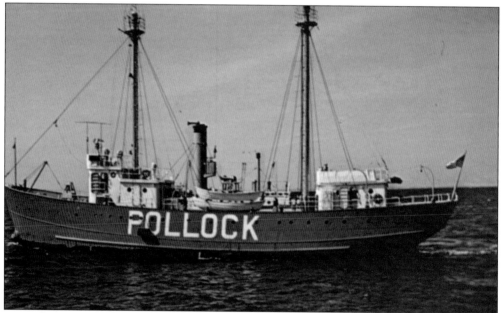

In the days before GPS and other modern navigational equipment, lighthouses were important aids to navigation. Where they were impractical to build, like on Pollock Rip Shoals south of Chatham's Monomoy Island, lightships were stationed. Seen in this postcard view, Pollock Lightship No. 114 was the last to serve on this station. It was reassigned in 1969, replaced by a buoy. (Courtesy of Joan Tacke Aucoin.)

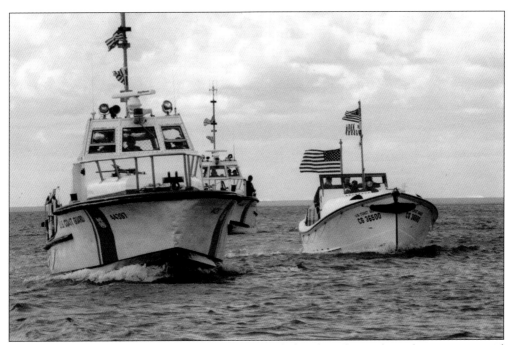

The majestic surf that helps make Chatham a special place has also made it a historic graveyard for ships. Not all Coast Guard rescue boats are up to the challenge of working the shifting sands at the harbor entrance, known as Chatham Bar. The 36-foot wooden surfboats like the famous CG 36500 (right) were replaced by steel-hulled 44-foot motor lifeboats (left). When those became obsolete, they were replaced everywhere in the nation except Chatham, where they remained until a modern near-shore lifeboat could be developed.

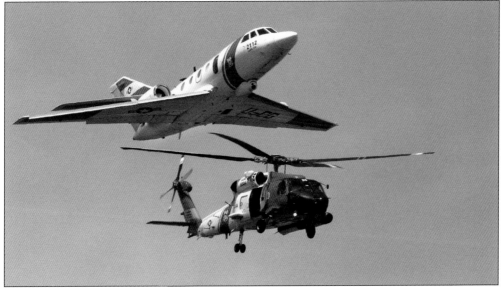

In 2009, when the Coast Guard decommissioned the CG 44301, the last 44-foot motor lifeboat in the national fleet, there was a ceremony at Station Chatham that included a flyover by a Falcon jet and a Jayhawk helicopter. The CG 44301 was expected to be put on display at the Coast Guard Museum in New London, Connecticut, but instead found a home on the front lawn of Station Chatham.

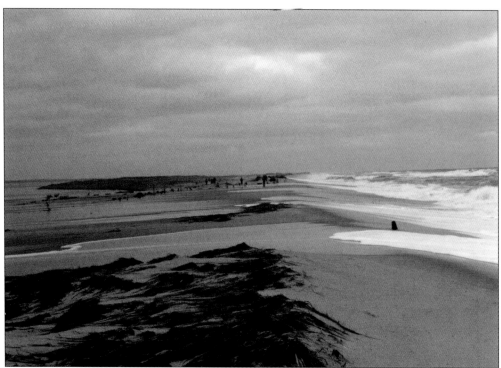

North Beach, which once stretched from Orleans to a spot opposite Morris Island, protected all of Chatham Harbor from the raging Atlantic. Late at night on January 1, 1987, the ocean scoured away the dunes and overtopped the barrier beach, as seen in the above photograph. By March, the washover had become a full-fledged inlet, pictured below. The break now serves as the main entrance to Chatham Harbor, roughly opposite Chatham Light. (Both, courtesy of Richard Miller.)

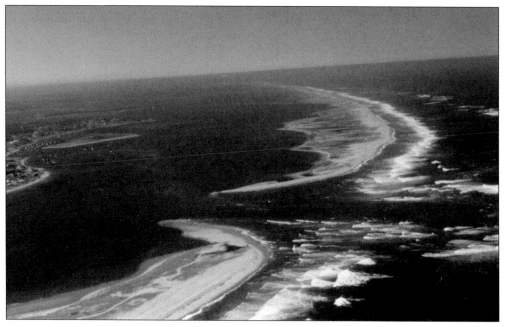

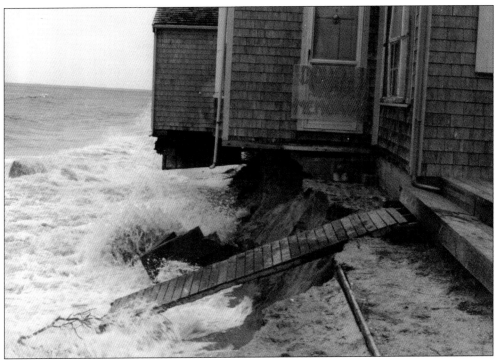

The break in the barrier beach allowed ocean waves and stronger tides and currents to batter the east-facing shore of the mainland, eroding away property and homes. A coalition of property owners organized as BREACH (Beach Reclamation Enactment Association of Chatham Harbor) lobbied for emergency installation of boulders designed to curb the erosion, but the measure proved to be too little and too late. The Galanti cottage was undermined by the waves, as seen above, and then—with network news cameras rolling—it toppled into the harbor on January 20, 1988. (Both, courtesy of Richard Miller.)

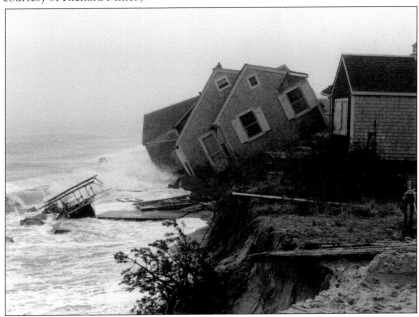

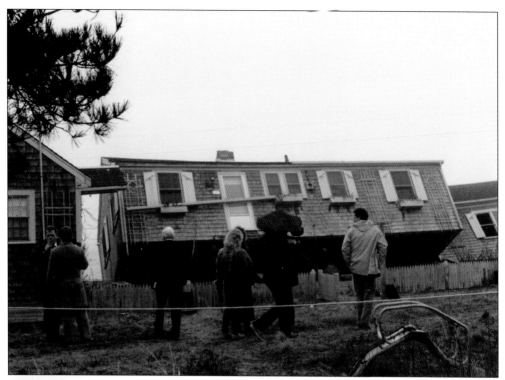

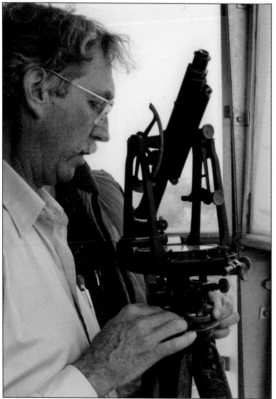

The loss of the Galanti cottage, seen above, came as the town was struggling to respond to the erosion that had already claimed the nearby Andrew Hardings Lane Beach parking lot. Working from the lantern room atop Chatham Light, coastal geologist Dr. Graham Giese of the Woods Hole Oceanographic Institution, pictured left, used surveying equipment to estimate the size and position of the breach. (Both, courtesy of Richard Miller.)

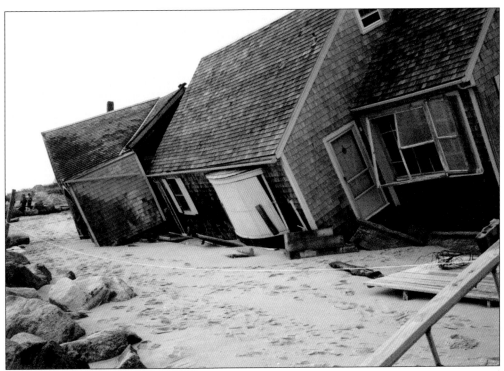

In the unsuccessful scramble to save the Galanti cottage, property owners and regulators waged legal and procedural battles. Homeowners had boulders placed along the shore, but the haphazard placement of the rocks seemed to only intensify the erosion. State officials decided that a more permanent revetment could not be allowed here because of rules that prohibit interference with coastal dunes. (Both, courtesy of Jason and Martha Stone.)

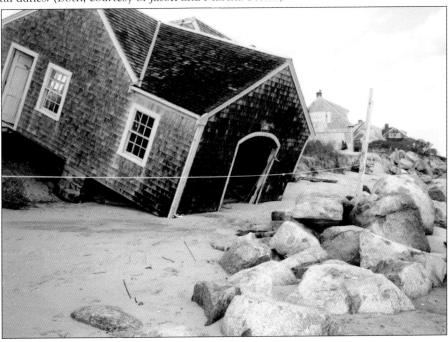

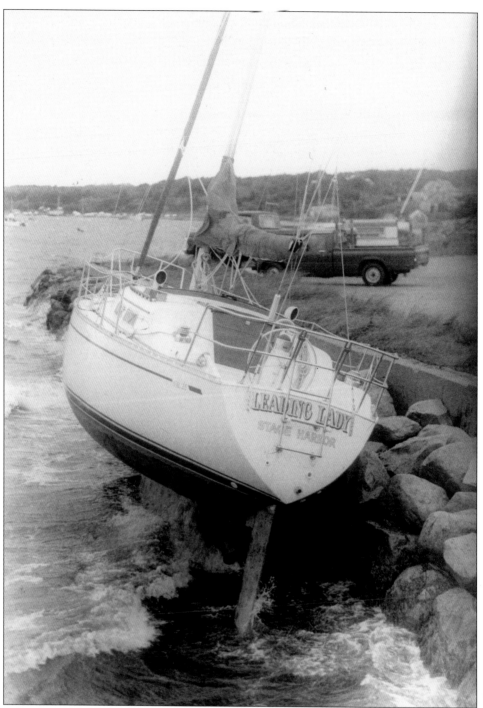

On August 19, 1991, Hurricane Bob struck southern New England, becoming one of the costliest storms in the Northeast's history. Though the brunt of the storm's fury was spent farther west, the Lower Cape experienced 125 mile-per-hour winds and a large storm surge that left south-facing harbors strewn with boats. Here, the *Leading Lady* rests on the rocks near the foot of Port Fortune Lane, Stage Harbor.

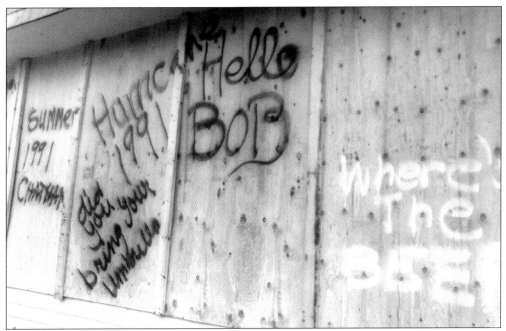

Hurricane Bob came ashore as a Category 2 storm and left some parts of Cape Cod without electrical service for more than a week. Before the arrival of the storm, some local merchants got creative with their plywood storm shutters, as seen above. When the winds subsided, Chathamites emerged to assess the damage. Battlefield Town Landing, pictured below, was littered with sailboats from Stage Harbor. No fewer than nine boats, from dinghies to oceangoing sailboats, form a tangled wreckage. (Both, courtesy of Richard Miller.)

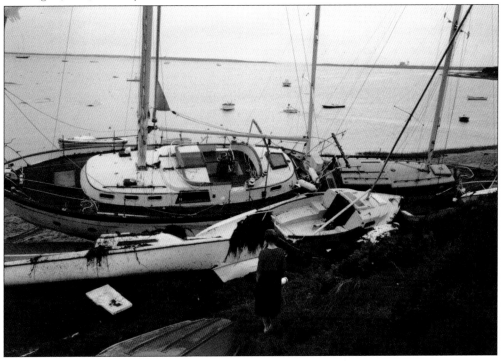

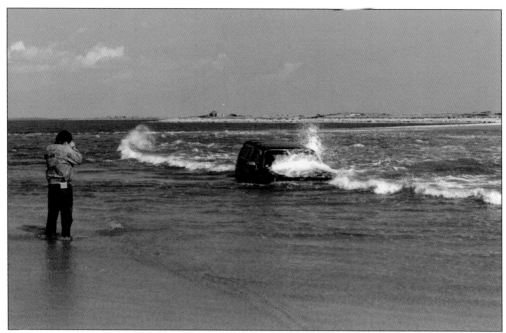

Easterly storms can cause changes in North Beach literally overnight. In October 1998, a four-wheel-drive vehicle on the barrier beach became stuck in soft sand near a washover and was quickly claimed by the tide. *Cape Cod Chronicle* reporter William F. Galvin snapped a photograph. (Courtesy of Richard Miller.)

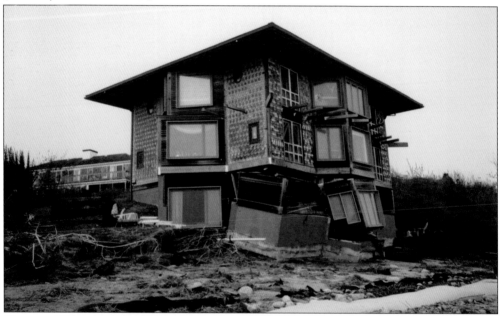

The year 1991 was not finished with Chatham when Hurricane Bob departed. From October 28 to November 2, the region was battered by the Halloween Storm, also called the No-name Storm and later—thanks to Sebastian Junger's book—the Perfect Storm. The Tina Durham house near Chatham Bars Inn sustained heavy damage from the easterly winds and storm surge. (Courtesy of Richard Miller.)

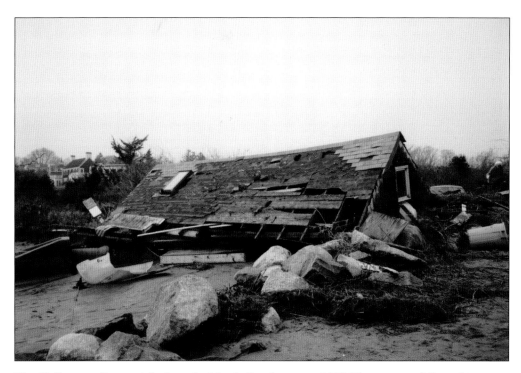

The Halloween Storm picked up the North Beach camp of Bill Hammatt and floated it across Chatham Harbor, depositing the wreckage near Cow Yard Landing, as seen above. Below, several fishing boats from Aunt Lydia's Cove washed ashore near the north jog of the Chatham Fish Pier, along with tons of debris. (Both, courtesy of Richard Miller.)

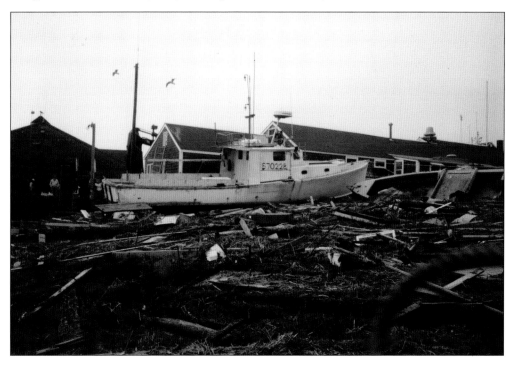

Winds gusted to 74 miles per hour in Chatham during the Halloween Storm, and massive waves offshore brought destructive surf to Chatham Harbor, thanks in part to the inlet that formed a few years earlier. On Old Wharf Road, the house that was once the North Chatham Post Office (above) came off its foundation. Truckloads of debris, including vegetation, fences, and structures from North Beach, had to be scooped out of the water near the Chatham Fish Pier. (Both, courtesy of Richard Miller.)

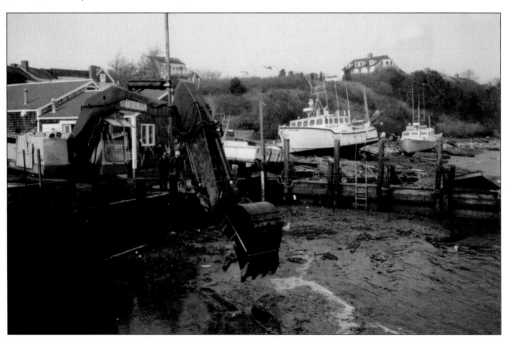

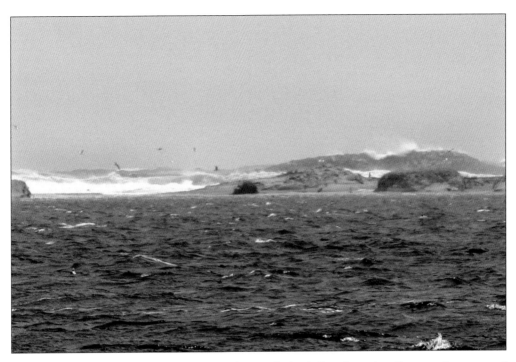

On April 15, 2007, a strong easterly storm battered North Beach, with tall waves that towered over the flattened dunes, as pictured above. The washover left the Second Village of camps isolated on an island. The view below shows the First Village looking north from the washover. The camps here were lost to erosion one by one, starting with the Russell Broad camp in the foreground, as the inlet widened.

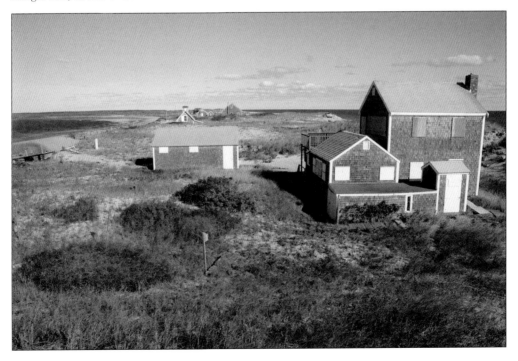

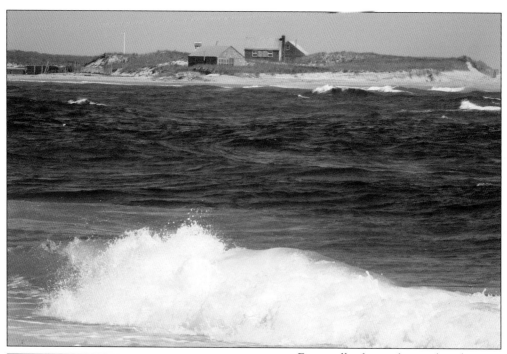

Eventually, despite hopes that the washover would fill in with sand, the 2007 inlet became well established. By the following July, it was wide and deep enough for small boats to navigate, as seen here. The inlet, roughly opposite Minister's Point, is expected to eventually become the main harbor entrance when the 1987 break fills in with sand.

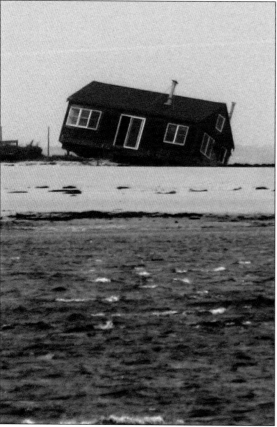

Steady erosion followed on both sides of the 2007 inlet, claiming the camps from the First Village to the north and from the Second Village on what was now called North Beach Island. By June 2009, a number of camps had washed away or were in need of demolition.

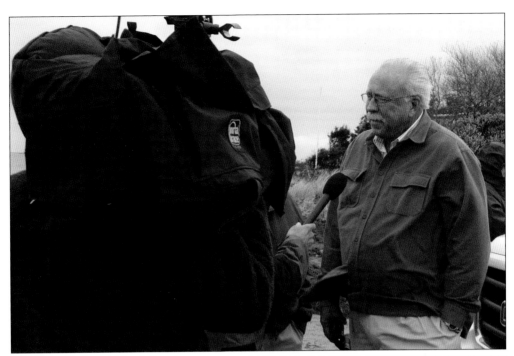

The loss of beloved North Beach camps was a human tragedy. One of the public faces of the story was Bill Hammatt, a tireless advocate for the rights of beach users. An eloquent spokesman and longtime member of the Cape Cod National Seashore Advisory Board, Hammatt died in 2013. Hammatt's Hangar was one of the last camps to go from the beach.

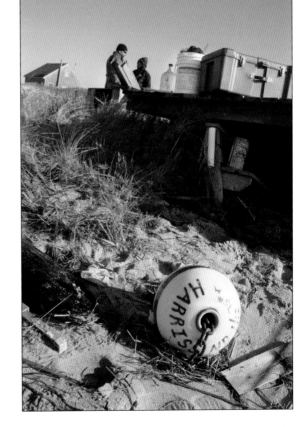

Most North Beach campers faced the loss of their camps with grim acceptance. Some of the buildings were dismantled or moved from the barrier beach, but most, like the Harriss camp, fell victim to the same beautiful ocean that lured owners to its shore year after year.

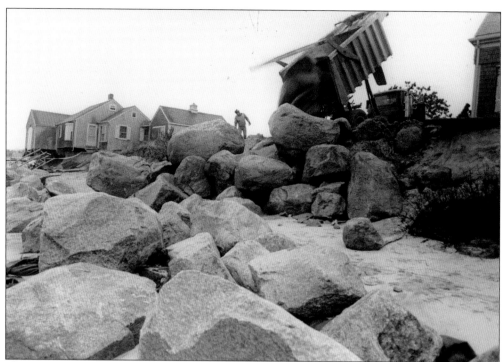

At best, battling shoreline erosion is a long-term commitment; at worst, it is futile. Armoring the shoreline with boulders and revetments, pictured above, causes only temporary benefits and moves the problem of erosion elsewhere. Revetments tend to starve adjacent areas of sand, as seen in the photograph below at Andrew Hardings Lane. In October 2005, the town trucked in sand to create an artificial dune to provide short-term protection for the area.

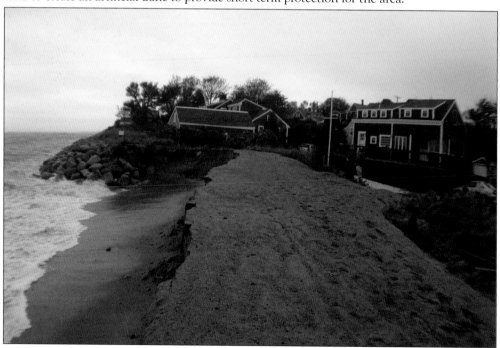

Six

NATURAL HERITAGE

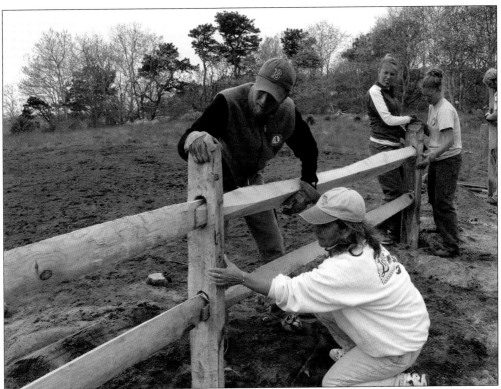

Preserving Chatham's natural heritage is the key to its future. Here, members of AmeriCorps Cape Cod work with the town's conservation agent in 2004 to install a fence at the Forest Beach Conservation Area. In addition to providing key grassland and salt marsh habitat, the former Marconi tract offers a stunning view of Nantucket Sound.

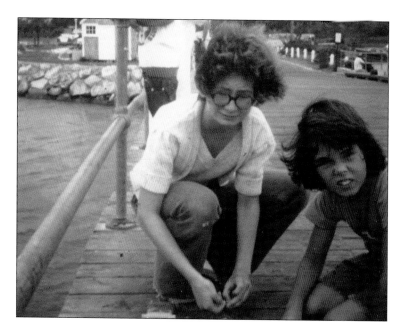

Generations of youngsters who summered in Chatham or grew up here spent their leisure time on the water. Here, Ellen Marx and Mark Fouhy fish off the Mitchell River drawbridge in July 1975. They caught mostly sea robins that had to be thrown back. (Photograph by Ed Fouhy, courtesy of Ellen Marx Zeyen.)

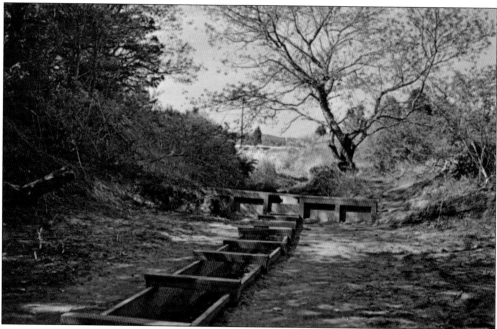

This undated postcard shows one of Chatham's lesser-known natural resources—the herring run connecting Ryder's Cove with Stillwater Pond. The fish ladder allows river herring in the ocean to reach the pond to spawn each spring. In 2006, officials halted the herring harvest as a conservation measure; low population numbers may be linked to overfishing or poor water quality related to shoreline development.

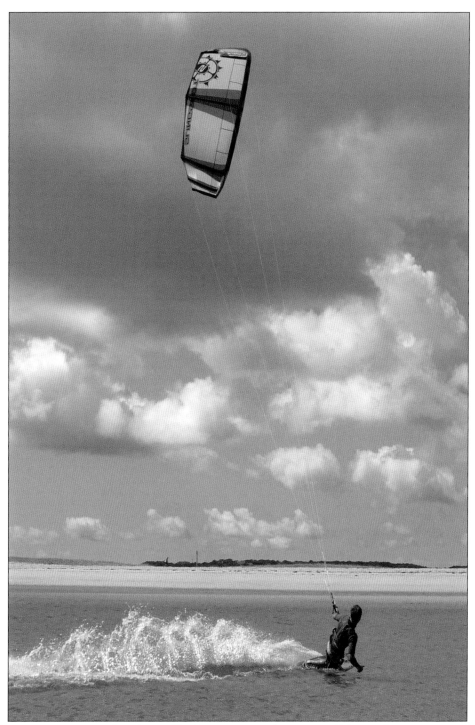

The economic engine that drives Chatham runs on clean water. Policy makers recognize that without pristine coastal waterways, the town could drive away summer visitors and second homeowners, harming the tourism and real estate industries. The human connection to the water takes many forms, like kiteboarding, a popular pastime at Harding's Beach.

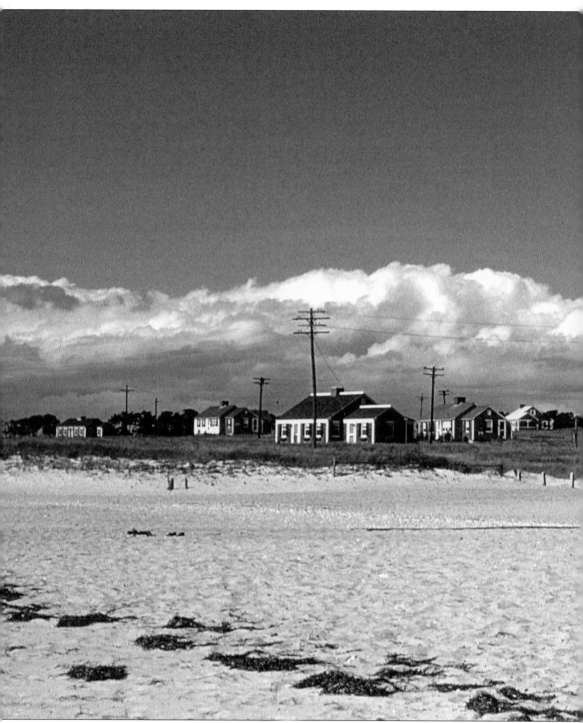

The residential development boom on Cape Cod since 1950 poses the primary threat to water quality. This 1956 view of Harding's Beach shows a scattering of modest cottages on the bluff west of the beach parking lot, where there is a dense neighborhood of luxury homes today. Chatham is close to "build-out," the theoretical point at which every buildable lot in town is

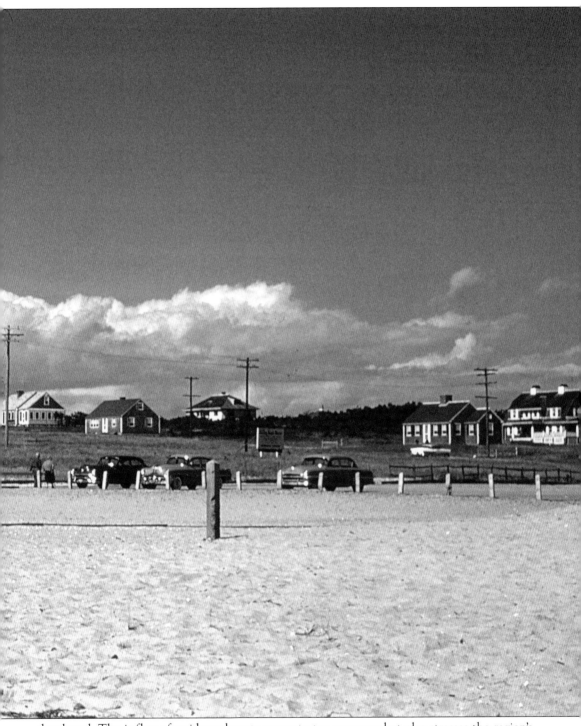

developed. The influx of residents boosts property tax revenues but also stresses the region's natural resources and infrastructure, like roadways. (Photograph by Martin J. Dempsey, courtesy of James J. Dempsey.)

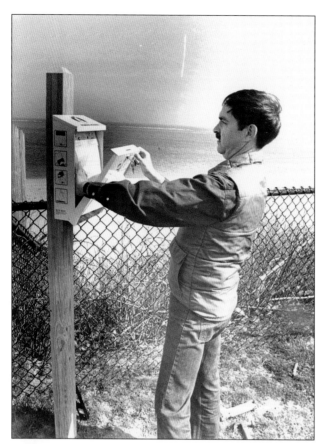

Chatham recognized the need to protect coastal water quality earlier than many surrounding towns, building a sewer system in 1972. From installing storm drains that treat road runoff rather than discharging it to waterways to promoting the use of "mutt mitts" by dog owners (left), the town has taken a multifaceted approach to water protection. In 2010, the town launched a 30-year sewer system expansion expected to cost hundreds of millions of dollars.

For years, an army of volunteer "Water Watchers" from the Friends of Chatham Waterways have collected saltwater samples from various beaches, creeks, and embayments around town. The water-quality data they generate has been used to form policy decisions about shoreline development.

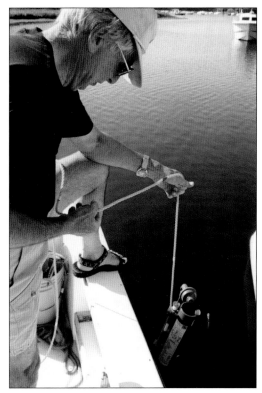

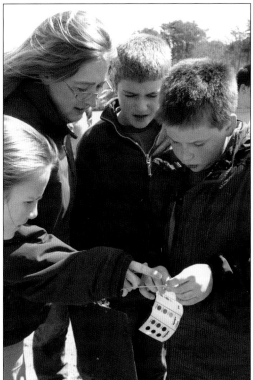

The nonprofit Friends of Pleasant Bay not only supports water-quality research, but also encourages the next generation of Chathamites to become guardians of the shoreline. Pictured in 2005, local schoolchildren check a water sample for salinity, nitrates, biochemical oxygen demand, and other important metrics.

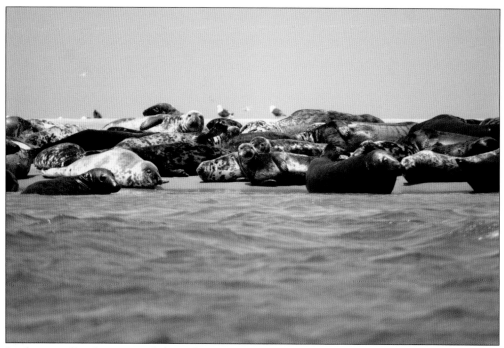

In the past decade, gray seals have begun to come to Chatham waterways in large numbers. Though they drive a thriving business for seal-watch tour operators, the seals also put pressure on commercially important fish species. Years ago, locals hunted seals to cash in on the $5-per-nose bounty the government had placed on them; today, the animals are federally protected.

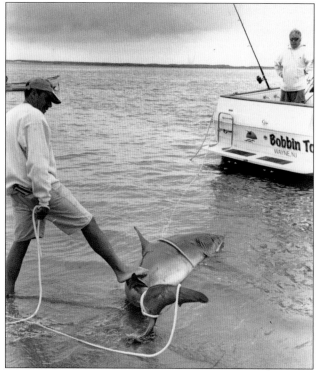

Sharks of various species have occasionally been seen in the waters around Chatham, with commercial and recreational fishermen spotting them most often, as in this undated photograph. It was not until 2009 when confirmed sightings of great white sharks began to increase in numbers. The predators are drawn to Chatham to feed on gray seals.

In 2009 during the busy Labor Day weekend, town officials ordered Lighthouse Beach closed to swimmers after white sharks were observed in the area, seen at right. The shark sightings made the news, and more people came to Chatham to try in vain to spot a shark. As seen below, downtown merchants capitalized on the frenzy, and sharks began appearing on everything from clothing and jewelry to cookies and candies.

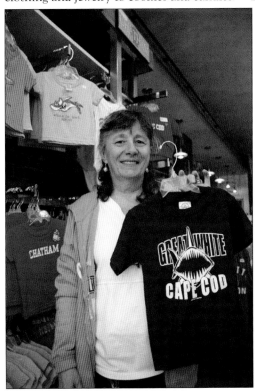

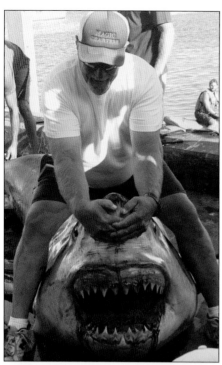

In September 2015, a 14-foot great white shark stranded on a beach at Wellfleet and could not be saved. Its carcass was towed to the Chatham Fish Pier where researchers conducted a necropsy, with a large crowd of curious onlookers observing. Fisherman Mike Abdow gave the crowd a *Jaws* view of the shark.

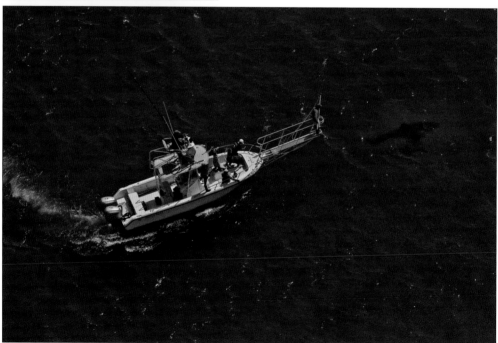

With critical support from the Atlantic White Shark Conservancy, the Massachusetts Division of Marine Fisheries is conducting a five-year population study of white sharks off Chatham. State shark biologist Dr. Greg Skomal, perched on the pulpit of the research boat, prepares to lower a high-resolution underwater camera that will later allow this particular shark to be identified. (Photograph courtesy Wayne Davis; www.OceanAerials.com.)

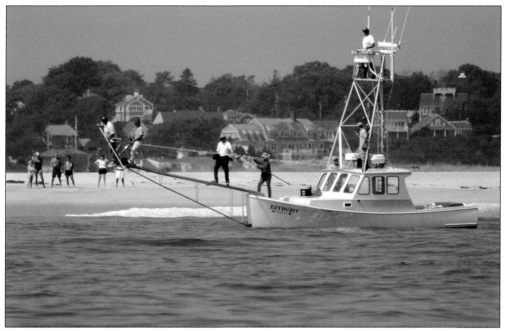

In other shark expeditions, Skomal uses a special harpoon to attach an acoustic transmitting tag on white sharks. Signals from the tags are picked up by receiver buoys, allowing researchers to know which sharks have been in certain areas at a given time. Beachgoers on North Beach Island watch the operation with understandable interest.

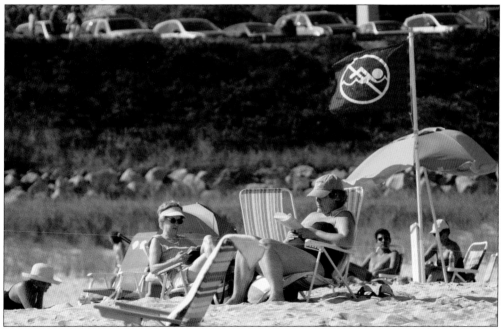

With no evidence that gray seals are leaving the area, white sharks are expected to be part of Chatham's maritime environment for the foreseeable future. The Atlantic White Shark Conservancy is working with town officials and business leaders to educate visitors about the best ways to avoid shark encounters.

For centuries before this young woman strolled the shore of the Oyster River in 1979, people have followed paths to the ocean that led them to Chatham. The lure of the community's vibrant summers and quiet off-season, its active community life, and its commitment to preserving the

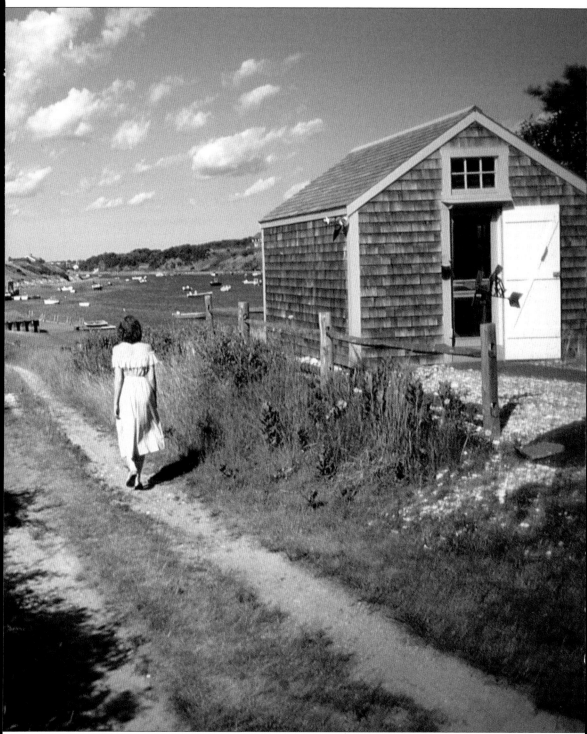

past all contribute to the town's appeal. But in the end, it is the call of the ocean that is heard.
(Courtesy of James J. Dempsey.)

DISCOVER THOUSANDS OF LOCAL HISTORY BOOKS
FEATURING MILLIONS OF VINTAGE IMAGES

Arcadia Publishing, the leading local history publisher in the United States, is committed to making history accessible and meaningful through publishing books that celebrate and preserve the heritage of America's people and places.

Find more books like this at
www.arcadiapublishing.com

Search for your hometown history, your old stomping grounds, and even your favorite sports team.

Consistent with our mission to preserve history on a local level, this book was printed in South Carolina on American-made paper and manufactured entirely in the United States. Products carrying the accredited Forest Stewardship Council (FSC) label are printed on 100 percent FSC-certified paper.